SKIN DEEP EXPOSURES Magazine
Naomi Mautz Photography (USA)
Copyright © Naomi Mautz Photography, 2013
All Rights Reserved

No part of this publication may be reproduced, stored in or introduced into a retrieval system, or transmitted, in any form or by any means (electronic, mechanical, photocopying, recording or otherwise), without the prior written permission of both the copyright owner and the above publisher of this book/ magazine and all photography contained within. The scanning uploading, and distribution of this book/ magazine via the internet or via any other means without the permission of the publisher is illegal and punishable by law. Please purchase only authorized electronic editions and do not participate in or encourage electronic piracy of copyrightable materials. Your support for the author/s and publisher is apperciated.

www.copyrightlaws.com/us/

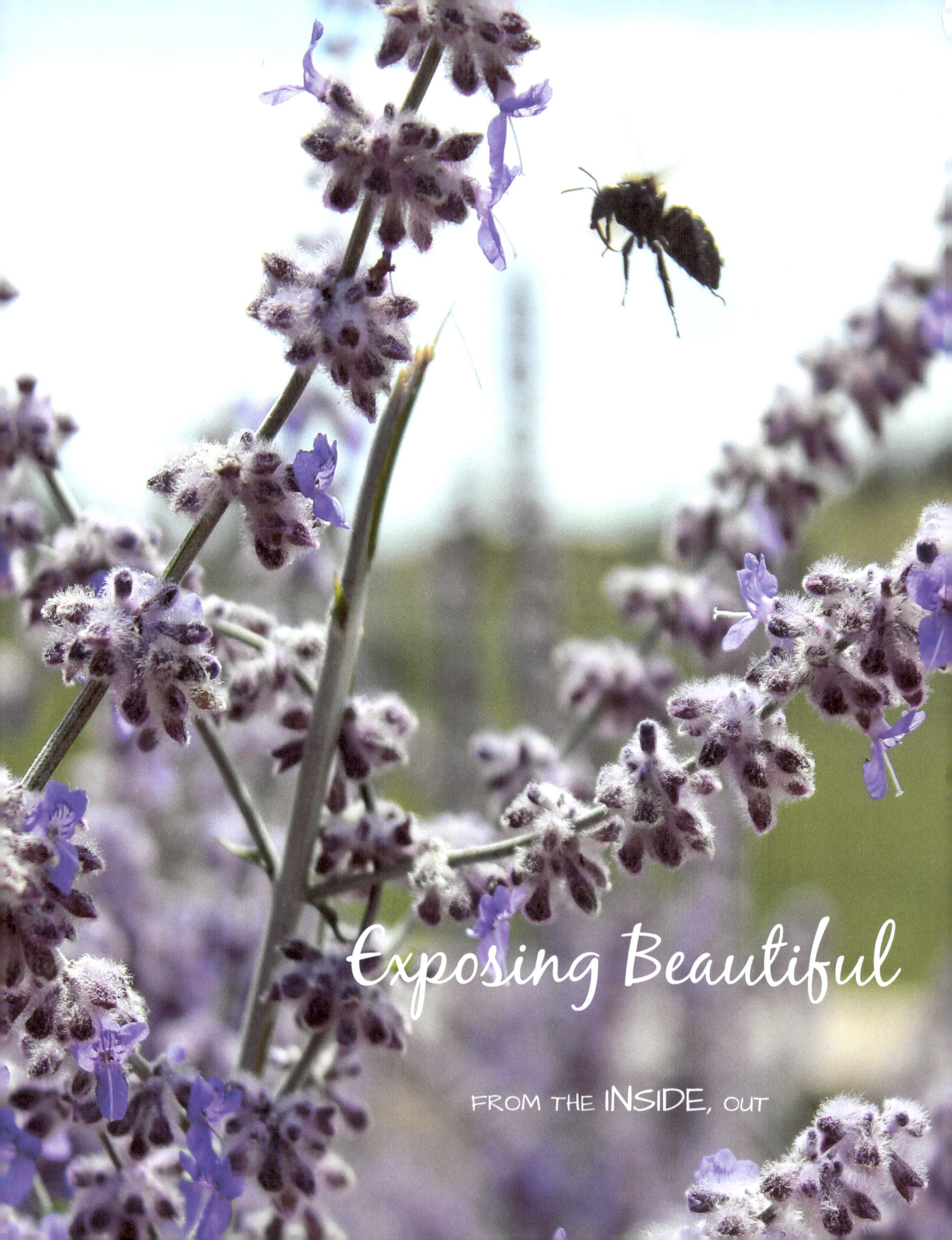

Exposing Beautiful

FROM THE INSIDE, OUT

SKIN DEEP EXPOSURES | *reflections*

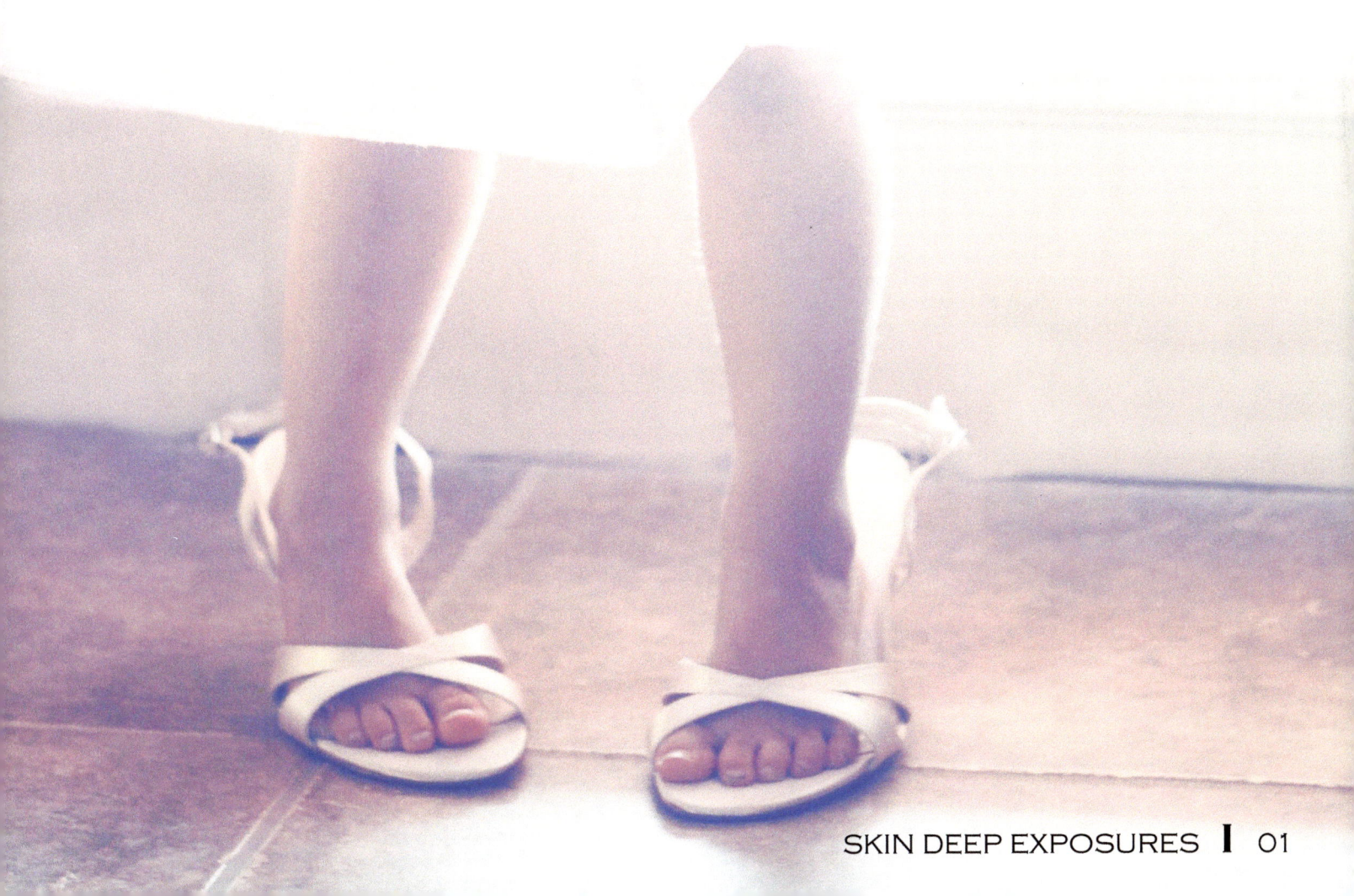

"It's not just the desire for an outward beauty, but more a desire to be *captivating* in the *depths of who you are.* Cinderella is beautiful, yes, but she is also good. Her outward beauty would be hollow were it not for the *beauty of her heart.* That's why we love her."

-STACI ELDREDGE-
Captivating

CONTRIBUTORS

founder, designer, writer, photographer
NAOMI MAUTZ

creative director, ads manager, writer
MICHAEL MAUTZ

senior editors
JOE & WENDY CARNS

editorials

freelance writer
KATY MARTURANO

freelance writer
CHRISTA WOLFE

women's interests

freelance writer
MELINDA THOMPSON

fitness & nutrition

personal trainer
MELINDA STRUSKA

special contributions

food hobbiest
SHELLY MCCALEB

freelance writer
SARAH COLEMAN

ADVERTISING

to advertise in Skin Deep Exposures Magazine
contact Michael Mautz
mmotzy@gmail.com

In this Issue

Back to School Mini Guide

A Commanding Beauty: The Male Box
MICHAEL MAUTZ
page 8

The Little Schoolhouse: A Photo Diary
MICHAEL & NAOMI MAUTZ
page 11

To Homeschool or not to Homeschool
NAOMI MAUTZ
page 17

I'ts Kind of a Funny Story
CHRISTA WOLFE
page 20

Fun and Easy Snacks to Fight the After-School Grumpies
MELINDA STRUSKA
page 25

Feature Interview
NAOMI MAUTZ
page 28

Life as I Know It: The Story of Me
SARAH COLEMAN
page 34

Bygone Beauty
MELINDA THOMPSON
page 40

Hiking Mis-Adventures: The Daddy Diaries
MICHAEL MAUTZ
page 42

Train for a 5K: Healthy Living
MELINDA STRUSKA
page 44

The Krafty Kitchen: Fall Favorites Recipe Mini Book
WENDY CARNS & SHELLY MCCALEB
page 49

For the Love of Teachers: Three Interviews
Shannon Custer: *61*
Sarah Mortensen: *65*
Chelsy Catterson: *69*
BY NAOMI MAUTZ

Idioglossia: Twin Talk
KATY MARTURANO
page 74

Credits 76

Mini Guide

BACK TO SCHOOL

A COMMANDING BEAUTY
The Male Box talks about beauty in the heart of a High School teacher.

TEACHER'S PET
We asked teachers about their favorite and their least favorite classroom experiences

THE LITTLE SCHOOLHOUSE
A photo diary.

HOMESCHOOL CONFESSIONS
"To homeschool or not to homeschool?" That is a BIG question.

HOMESCHOOL RESOURCES
Our favorite websites, blogs and links for helpful information, advice and free materials.

IT'S KIND OF A FUNNY STORY
Christa Wolfe

MANAGE AFTER SCHOOL GRUMPIES
Fun and easy after school snack ideas

THE MALE BOX
A Commanding Beauty
BY MICHAEL MAUTZ

I was recently asked if I had any teachers that stood out to me over the years.
I didn't have to give the question much thought as the memory of one teacher in particular swam to the surface.

She was blonde with pale skin and a petite frame. She was studious, athletic, soft-spoken, and had a playful sense of humor. Her name was Mrs. C. and she was my High School English teacher. Mrs. C. was always simply dressed with little makeup and low fuss hair. She was not one to be consumed by a sense of fashion (though she always looked nice and was very pretty). She was comfortable. She always looked comfortable and she made all those around her feel comfortable.

I realize that I may have just described a good portion of the teacher population out there for high schools in small town America. The thing is my high school was not located in small-town America. I went to school in Vallejo, California and in this particular high school the terms gang and ghetto were not just part of our daily vernacular they were often descriptions of our lives. By her appearance alone, Mrs. C. stood out like a sore thumb. But for a kid caught in the middle of a rough and dangerous environment, just looking to survive a life of circumstances outside of his control, Mrs. C. stood out for much greater reasons than the visual contrast she presented to her environment.

She had a way of communicating a genuine care and love for each of her students as individuals. She never saw race, culture, gang affiliation or our status with the local juvenile detention center. She saw us all as individuals, high school kids going through the awkwardness of puberty, dealing with where we fit in socially and attempting to figure out who we were and what we stood for. She cared about her job as a teacher and took seriously her part in overseeing our educational development as well as our character development. She had high expectations and held us to a standard that demanded we step up to our potential. In a school where survival demanded certain actions and attitudes to be adopted, Mrs. C. never shied away from demanding our very best performance. She would allow nothing less even as the majority of the student population worked to convince the world that things like English Literature didn't have a hope of ever holding the slightest bit of our interest. After all, gangsters and thugs don't need Shakespeare.

Mrs. C. would walk undeterred through the classroom as she read from the classics. Her love for her job and her belief in our potential never waivered as complaints of disinterest were brushed aside and excuses for under-achievement were unacceptable. In a way that only she could, she managed to inspire a love of literature and a thirst for knowledge in a bunch of young, punk High School kids who were otherwise on a fast train headed nowhere. For someone like me this was the equivalent of opening up a door to a whole new world. Under her encouragement and mentorship, I began to develop a passion for learning and even reading!

Aside from all of the educational lessons she imparted, she reminded us that we each held a potential beyond our present circumstances. We were responsible for our own future and we were accountable for our own actions and decisions in the midst of our circumstances with no excuses. She had this amazing way of mothering us without actually mothering us. The bottom line was we knew she cared about us and she expected us to care about ourselves.

I fondly remember the way she would playfully (and naively?) poke fun at a few of the local gangster trademarks like "tagging". Graffiti at a school like Vallejo was more than common. Mrs. C. once walked into the class in mocking frustration at the most recent tag on a newly painted wall. In a huff she announced, "I just don't get it. I'm going to go out there and write 'Ms. C.' all over your houses and property with my spray cans." The visual of this was so ridiculous that we all burst out laughing. Masterfully, she had communicated her point that this form of vandalism was ridiculous and expressed an immature level of disrespect.

The very few times I remember anyone attempting to disrespect Mrs. C. were always met with a resounding silence as the entire atmosphere grew rather menacing. You would've thought the individual in question had just simultaneously insulted everyone's mom. Some of the biggest, roughest looking students in the class would make slight defensive adjustments in their seats and their glances would become challenging. The implied statement was clear, "You have been warned and it is far better for you to just shut your mouth and be on your way to the principal's office than deal with whatever might be waiting for you after class".

While our circumstances remained and the obstacles we faced in that school did not magically evaporate, for one hour every day, we all got to be surrounded by a sense of love, acceptance and a mutual respect that wasn't to be had anywhere else in our lives. An hour each day may not seem like much, but it was. That hour was one of the few times during those High School days that some of us were ever challenged to discover ourselves, recognize our potential and for the first time see the hope of a future that held something more for us.

TEACHER'S PET

By Naomi Mautz

We got the inside scoop on the inner thoughts of a few elementary school teachers. We wanted to know what their favorite, their funniest and their not so fantastic experiences have been over the years in their classrooms.

GIFTS

The best gifts that come from students are the flowers they pick or the rocks they find at recess. I have students come up to me with flowers or pretty rocks they found and say "This is just for you Ms. C!" It really melts my heart. I also love it when students draw me pictures. I hang every picture up on the wall by my desk. It is the small things in life that matter the most!

PARENTS

The most helpful thing parents can do is reinforce academic and behavioral concepts at home with consistency. This keeps a connection between home and school. When a parent is willing to communicate with me about their child's life and education and show support and collaborate on how to best teach their child, it makes a world of difference.

PET-PEEVES

Bullying and lack of kindness goes without saying. As a teacher, I think my biggest pet peeve (as silly as it sounds) is when the students ruin their pencils. Students will purposefully break off the erasers, chew on the pencils, bend the metal around the eraser part, or purposefully break the tip off of their pencil. I am trying to teach my students that pencils are a tool and not a toy. It drives me bonkers when I find a pencil with the eraser torn off (haha)!

SUBJECT

My Absolute favorite subject is Reading!
I love teaching students how to read; the joy of reading and writing. Literature is fun for me to teach. It is my strong suit. I wouldn't say I have a least favorite subject to teach, but I would say the one that is the hardest for me to find fun activities for is history. You have to spend a lot of time getting extra creative to get the kids involved and interested in history. But I do love to teach all subjects because they all have their pros/cons.

STYLE

I would describe my teaching style as positive, fun and loving. I try to provide a safe and structured environment where children learn to make responsible choices. (Sarah Mortensen- Colorado Springs, CO.)

My teaching style is getting the kids out of their seats, moving around, interacting with each other, being involved in their own learning, and teaching their peers as well. My philosophy is "whoever is doing the most talking is doing the most learning." (Chelsy Catterson- Colorado Springs, CO.)

LOL

Wow....funny things happen to me all the time. A recent instance was when I wore my hair kind of wavy one day, rather than my regular straight hair. I had a little girl come up to me and say, "Your hair is crazy today! Did you even brush it?"

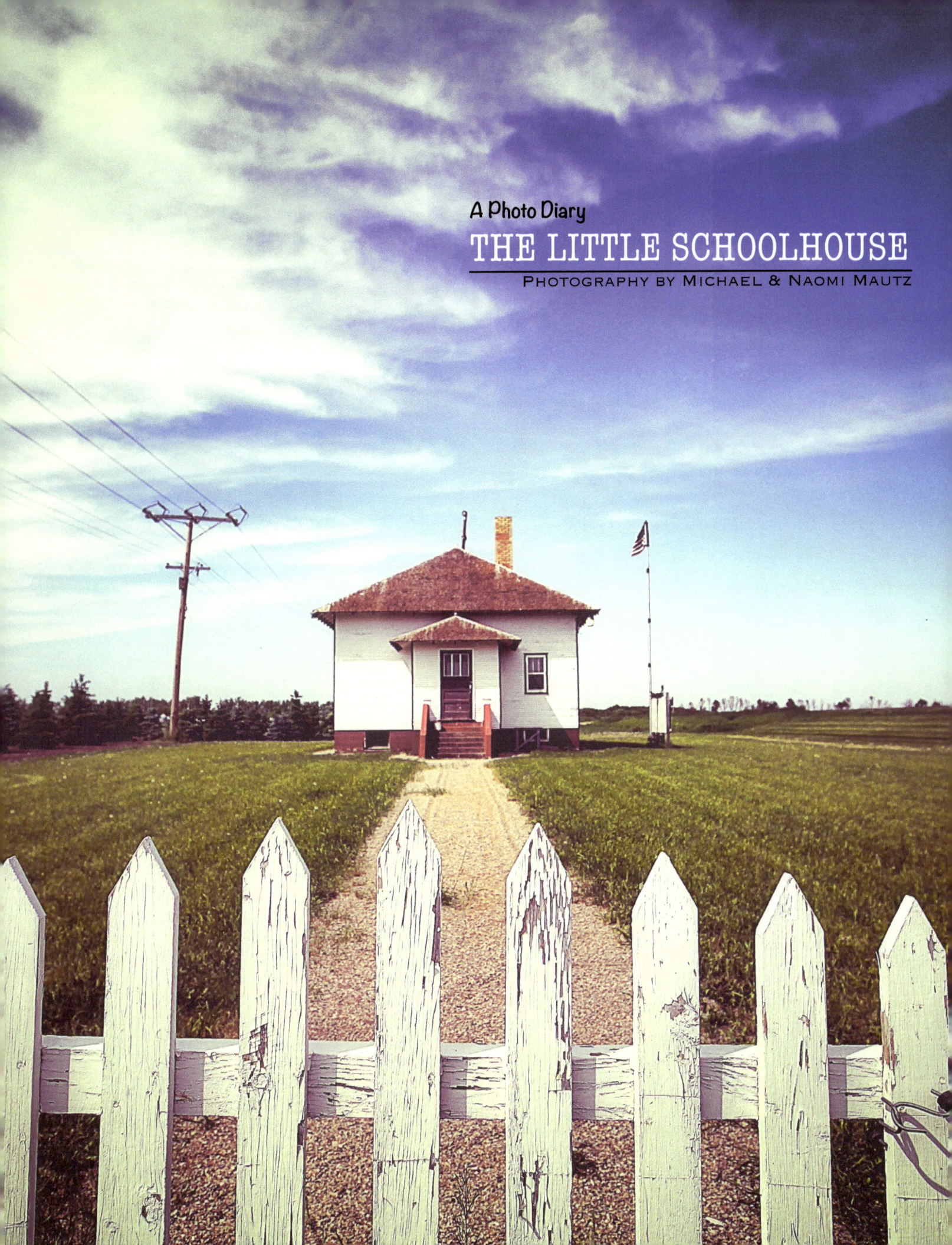

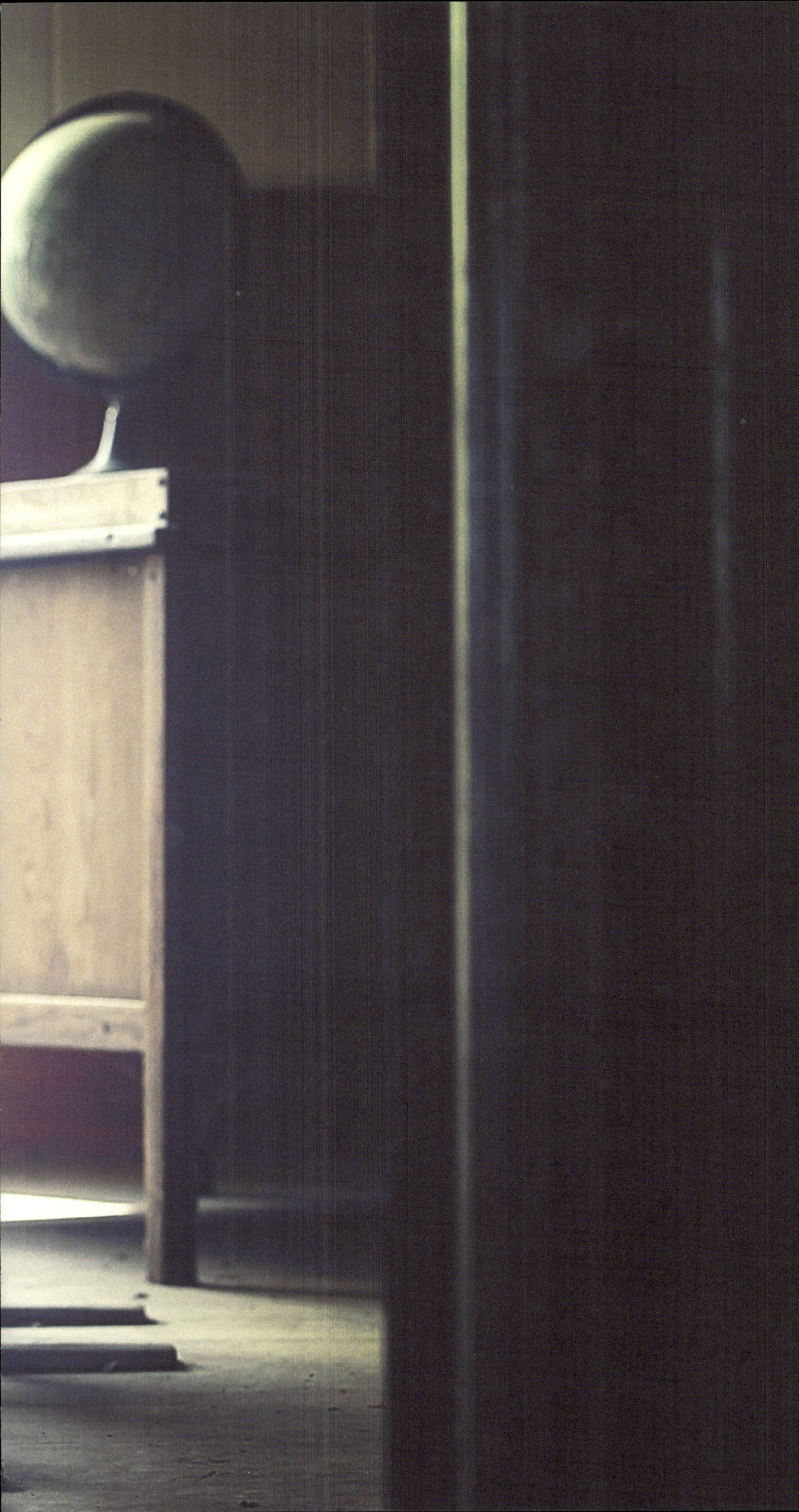

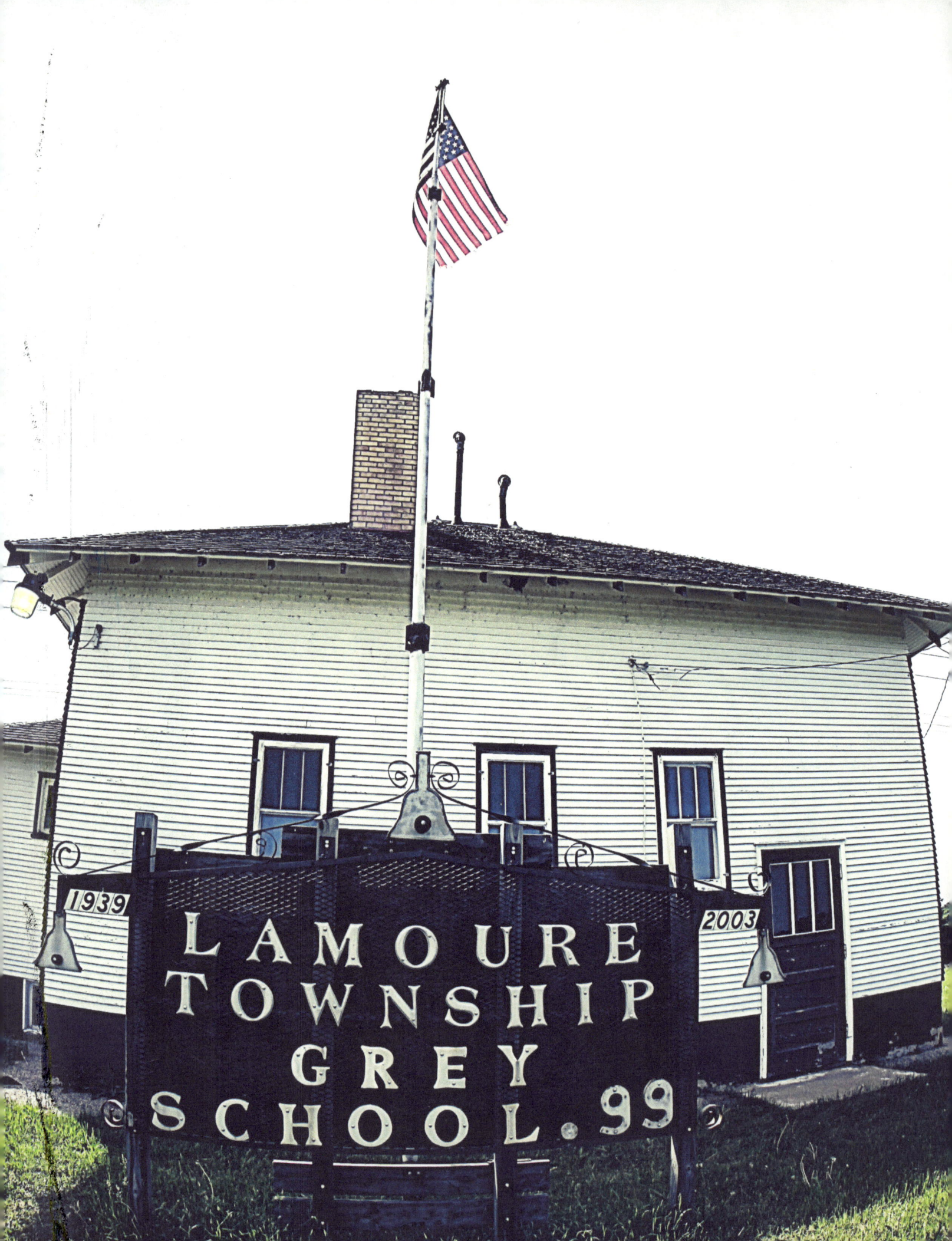

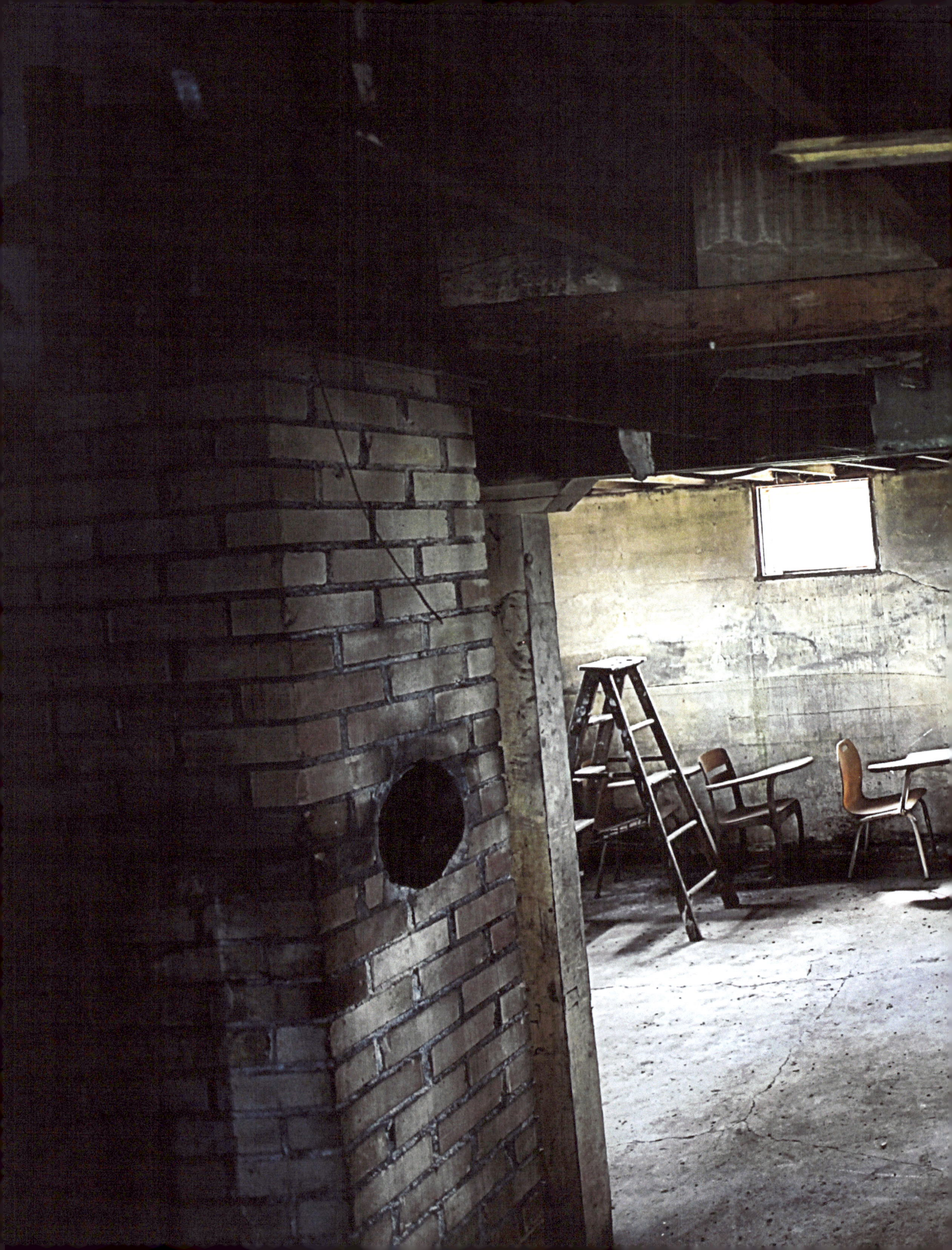

To Homeschool or not to Homeschool?
THAT IS A BIG QUESTION
by Naomi Mautz

My husband and I made the decision to begin homeschooling three years ago. The decision was made at the last minute about one month before our oldest child was scheduled to begin first grade. We had been debating the decision back and forth for years. The main hold-up was me. I was the one who would have to take responsibility for the endeavor. It was me who would be staying home all day acting as teacher for our roudy bunch. The decision was finally made as a reaction to some major changes that were taking place at our daughter's current charter school, changes we did not agree with. It was now too late in the year to get her into any other private or charter schools and all of the waiting lists were a mile long. Thus, the decision was made for us and off to the local homeschool supply store I went. I had no idea what I was doing or what I was getting myself into. YIKES! I learned rather quickly that I was in way over my head. This homeschool thing was not for the faint of heart! To make a very long story short, it took a better part of the entire first year for me to get my legs underneath of myself. The whole year was pretty much an epic failure academically. Luckily it was a year free of standardized testing, WHEW! It was also a year of pure blessing for our family. In spite of the hardships, the sleeepless nights and the rivers of tears I cried as I sat, overwhelmed at my computer, drowning in advice, materials and blogs about homeschool moms who had it all together, we watched our children blossom! The time they spent with myself and with eachother throughout each day was such a wonderful gift for all of us. In that year I got to know each of my children in ways I never would have imagined. I got to share in their entire days, watch them learn new things, discover their passions and their abilities and help them overcome their obstacles. It was wonderful! It was time consuming, stress filled and a serious lesson in patience, but it was wonderful!

I have been asked on a few occasions, by friends facing the decision of homeschooling, to share my thoughts, advice and wisdom (haha) from my own journey as a home school mom. I will be the first to admit that I am probably not one to be looked to as an expert on the subject (as I am still very much a newbie at all of this). My humble advice, however, is this;
As a homeschool mom trying to balance running my own business, planning lessons that can span the age gap, keeping the house in order, the family fed and my sanity in tact... sometimes it is necessary for a little time out to remind myself that I am doing a great job. The process of planning and preparing for daily lessons can become extremely daunting at times and these seven things have become necessary to my survival;

1. It is important to stay as organized as humanly possible.
2. This is a tough one now. Remember that you are not superwoman, as much as we would all like to believe that is possible.
3. Dont make the process too complicated, keep things as simple as possible.
4. Keep good records.
5. Stay social. Keep your kids involved socially so they do not become isolated. Check with the local library for their homeschool activity schedule. Sports and after school programs are also a good way to keep the kids connected. Remember to take time to keep up with your own social time as well even if it is just coffee with a friend! Trust me, this is your sanity we are talking about.
6. Don't put too much pressure on yourself. Your kids do not have to rank on the genuis scale, so give yourself a break and do what you can and let that be enough.
7. Finally, take time out to rest. Make sure you have at least one day each week that is NOT about school. Lock the schoolroom door and refuse to go near it or even think about it for a full 24 hours each week. Sit in a nice warm tub in a quiet bathroom, with the door locked and just breathe... and chocolate helps.

Making the decision to homeschool is a HUGE one. It is a decision that should not be taken lightly. Before you make the leap make sure you find a support group! Do not go at this alone. You will burn out before you have even gotten started. Also, make sure you do your research! Get to know the homeschool laws in your state. Make sure to find a cirriculum that works for you as well as great resources and websites that you can turn to for materials and advice.

One of the biggest headaches in homeschooling (for me anyway) is finding curriculum! I often walk into a store or pull up a website at the beginning of each year and gaze longingly at those beautiful boxes that proclaim to have mastered the magic of a one stop shop, accross the board curriculum for your whole year... you just pay the exorbitant fee and all of your homeschool worries are over. Just open the box and you are good to go, YIPEE! (Oh how I wish!) In my own trial and error process that is homeschool curriculum, I have found that it is just easier to bite the bullet and do my research. The internet is abounding in wonderful sites for homeschoolers in need of some inspiration and even fully prepared ideas for lesson plans (God bless the wonderful souls of those who somehow find the time for this endeavor) but they are out there! I have put together a resource list of a few of the jewels that I have found and LOVE! There are many many more out there so keep looking until you find a few that work best to encourage and insipre you! Above all, make sure that homeschool is the right decision for your family. You are NOT a bad mom/dad for not homeschooling. Sometimes it just isn't possible and that is okay! If you do homeschool just remember that you can only do your best and that is enough! Enjoy the time with your kiddos. It goes by WAY too fast!

Good Luck!

Resource Center

Helpful Homeschool Links

LEGAL RESOURCES:

HSLDA- Home School Legal Defense Association
http://www.hslda.org
HSLDA is a nonprofit advoacacy organization designed to defend and advance the constitutional right of parents to direct the education of their children and to protect family freedoms. Through this website, parents can find homeschooling legal advice and support, state laws, forms and organizations. They also provide support groups a comprehensive guide for new homeschoolers, tips and support for struggling learners and cirrciculum options and advice.

Colorado Department of Education - Homeschool page
http://www.cde.state.co.us/choice/homeschool.htm

FIND A SUPPORT GROUP:

Homeschool World
home-schoolworld.com/support

WEBSITE AND BLOG RESOURCES:

Writing-

Really Fun Writing
www.reallyfunwriting.com

Arts & Crafts for the Classroom-

Deep Space Sparkle
www.deepspacesparkle.com
Art ideas and downloadable lesson plans.

The Crafty Crow
http://belladia.typepad.com/crafty_crow/
Get great craft ideas to supplement your homeschool cirriculum.

Computer and Keyboard Skills-

InTec InSights
http://www.karenogen.blogspot.com

Mathematics-

IXL
www.ixl.com
Math skill development for grades pre-k through eighth grade.

A Little Bit of Everything-

Confessions of a Homeschooler
www.confessionsofahomeschooler.com

Minds in Bloom
www.mindsinbloom.com

Delightful Learning
www.delightfullearning.blogspot.com

Mama Jenn
www.mamajenn.com

Ladybug's Teacher Files
http://www.ladybugsteacherfiles.com

Activity Village
www.activityvillage.com

Love and Logic
www.loveandlogic.com

Click Schooling
www.clickschooling.com
Daily cirriculum ideas.

Donna Young
www.donnayoung.org

Be sure to check out your local public library for Homeschool programs, book clubs and events!

Home Schooling 101

by Erica @ Confessions of a Homeschooler

"While I realize that all homeschools are different, new homeschooling families still need a tangible starting point. With over 100 pages of valuable information and tools, Homeschooling 101 will guide you through your homeschooling process!"

- Erica Arndt (Confessions of a Homeschooler)

Inside You will find:

- Chapter 1: You've Decided to Homeschool... Now What?
- Chapter 2: Choosing Curriculum
- Chapter 3: Gathering Curriculum
- Chapter 4: Creating Effective Lesson Plans
- Chapter 5: Getting Organized
- Chapter 6: Starting School - Day 1
- Chapter 7: Homeschooling Multiple Grades
- Chapter 8: Homeschooling & Discipline
- Chapter 9: Standardized Testing
- Chapter 10: Homeschooling with Toddlers
- Chapter 11: Homeschooling Your Preschooler
- Chapter 12: Homeschooling Kindergarten & Elementary
- Chapter 13: Homeschooling Jr. & High School
- Chapter 14: Homeschooling on a Budget
- Chapter 15: Starting Homeschool Midyear
- Chapter 16: Switching Curriculum Midyear
- Chapter 17: Homeschooling an Only Child
- Chapter 18: Homeschooling & the Working Parent
- Chapter 19: Homeschooling & Special Needs
- Chapter 20: What about Socialization?
- Chapter 21: Time Management & Keeping your Sanity
- Chapter 22: Homeschool Burnout
- Chapter 23: Staying the Course & Naysayers
- Appendix (Helpful Homeschool Forms)
* Resources & Links

ORDER YOUR COPY @ CONFESSIONSOFAHOMESCHOOLER.COM
GET THE KINDLE EDITION ON AMAZON.

WELL, IT IS KIND OF A FUNNY STORY...
By CHRISTA WOLFE

Back to school, back to reality. The shenanigans of summer are over, and we have to face the fact as parents that our children need an education. Whether we send our kids to public school, private school, or educate them via home school, we know deep down our little kindergarten prince or princess is the future President of the United States. We need merely to watch their genius bloom into the brilliance that we know, without a doubt, it will. I did say, "back to reality," right?

I am now blessed with five children, but I distinctly remember sending my beautiful first born and only baby girl, through the doors of her first school and thinking I was releasing my newly inaugurated kindergartener into the place that would nurture and grow her obviously well-tuned and advanced intellect into a raging fire of knowledge. I made the perfect lunch of cream cheese and jelly on whole wheat bread with carrot sticks, cheese slices, and a box of all-natural fruit juice. It was a lunch of champions and I was the perfect mother. Well, not quite, because as my baby stood in line, picking her nose, I paused and fought the urge to reprimand her in front of her peers. Somehow I must have forgotten to tell my angel that being knuckle-deep in nostril was probably a turn-off to potential friends. In my confusion I let her continue to dig for the elusive booger, allowing myself to think positively about her obvious ability to persevere. Oh yes, this is a future leader, for sure!

Well, this year is my baby girl's senior year of high school. Wisely, she has abandoned nose-picking and developed abilities far out-reaching any that I have instilled. She has survived public school, home school, being dual-enrolled in both, and having a mother who started weeping during eighth grade math instruction. However, I feel confident that, even though on most days I am chasing her out the door to get her to choir and theater classes on time, and throwing bags of uncooked ramen noodles at the back of her head (in lieu of the aforementioned lunch of champions), I truly believe that she is almost ready to be released into the wild. She is embarking on the journey which will take her far from home and leave me swimming in a pool of testosterone alone. Her dad and four brothers are all very manly men and I have yet to instill a true appreciation for the drama and intensity of cramps and bloating. I have been plagued with the fear of "parenting failure" many times. This most often happens when I am confronted with questionable understanding or a lack of retention. Even when accosted with my mediocre teaching abilities, she flourishes with ambition and a drive to succeed. My baby has distinct plans for the future, thankfully not involving the application of eyeliner and a dramatic monologue.

Despite my inability to comprehend calculus or why anyone in their right mind would want to wear skinny jeans, my children will continue to thrive in whatever direction fits their personality. I am, by no stretch of the imagination, even close to a perfect parent. "Perfect parents" are like unicorns. Everyone wants to have one, but no one has ever seen one, and if you did see one, you were probably under the influence of some drink, drug or plant. They DO NOT exist. So take comfort. We are human parents with human children destined to fail in some parts and succeed in the parts that matter. We start our children's education with visions of grandeur and end at their senior year, hoping that their hot dog suit from Whataweenie fits without sagging. Life takes over, personalities bloom into ambition or ambivalence, and we love our children just the same. I have five distinct, human, personality-filled offspring, and they all make me feel big or small, depending on the day and circumstance, and that is okay. I have not failed.

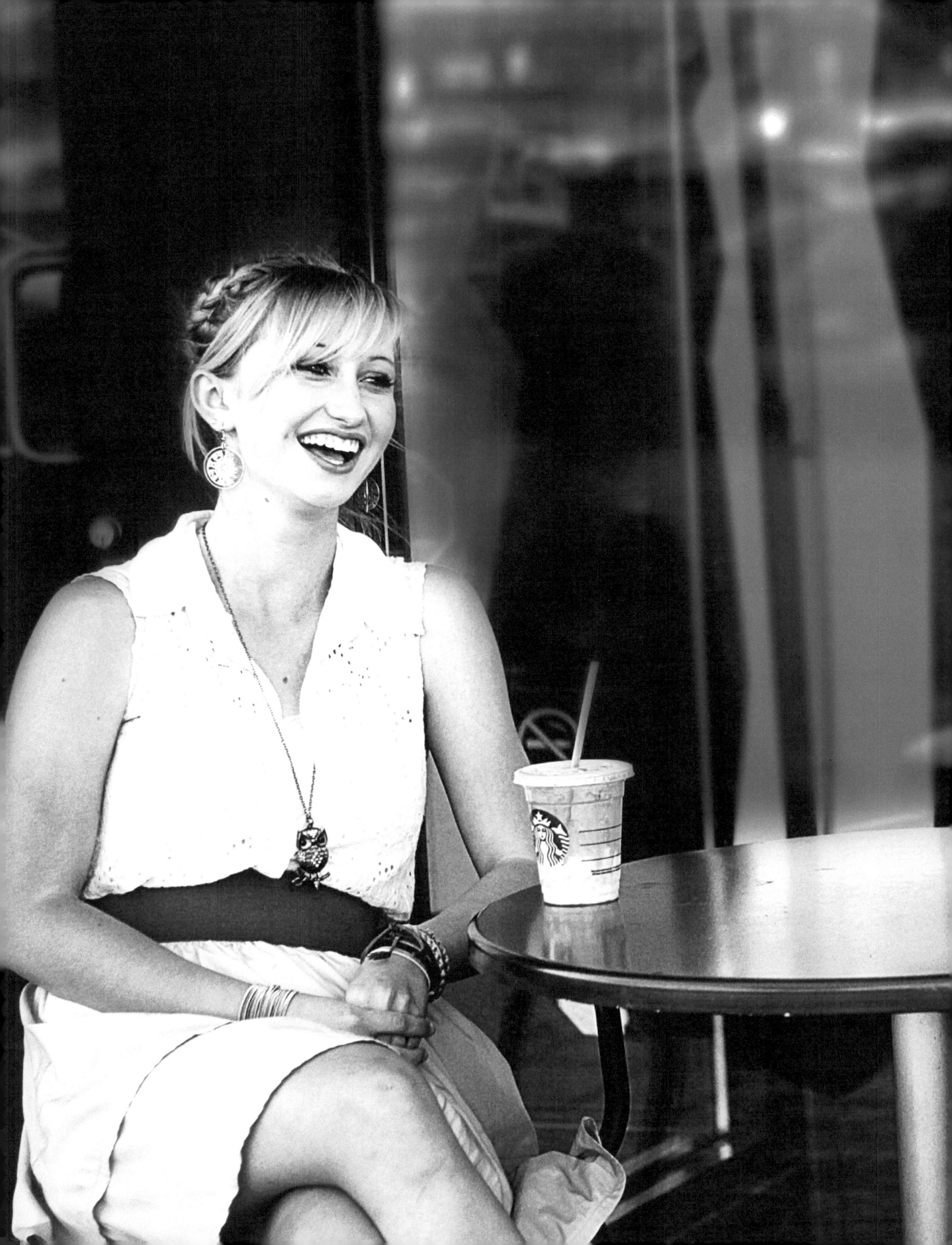

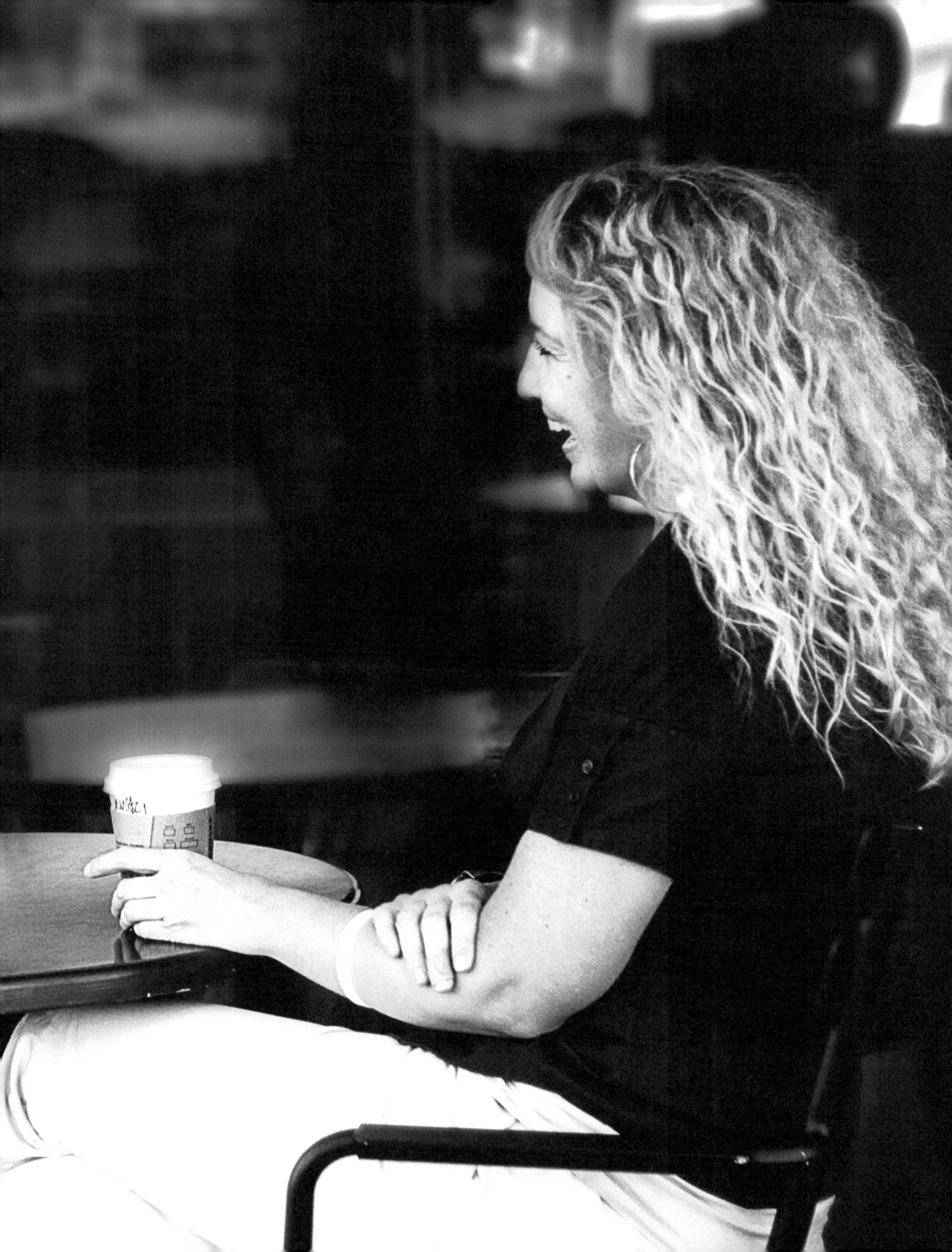

ASHLEY.ROE
Pink Papaya
www.pinkpapayaparty.com/coacheswife2010

products infused with botanical extracts
made in the usa
no animal testing
heads to toe paraben free options

719.784.1383

Relax,
Recharge,
Renew.

Fun and Easy Snack Ideas
to manage the "After School Grumpies"

A full day of school is an energy draining experience. By the time the last bell of the day rings, most kids are in dire need of something to jump start their energy levels. Give them a snack to look forward to with these fun and easy crowd pleasers!

Chocolate Apple Flowers

1 - 2 Servings
Prep time: 5 minutes

1 Apple

5 tbsp. Nutella™

3 tsp. Oatmeal

3 tsp. Chocolate Chips

Large flower shape cookie cutter

Small cookie cutter

1. Wash apple carefully and cut into thin slices (approx 1/4 inch thick)

2. Use the large cookie cutter around the outside of the apple slices. Cut out the center of the apple with small cookie cutter

3. Spread Nutella™ on top of the apple slice and then sprinkle with oatmeal and chocolate chips. Eat up!

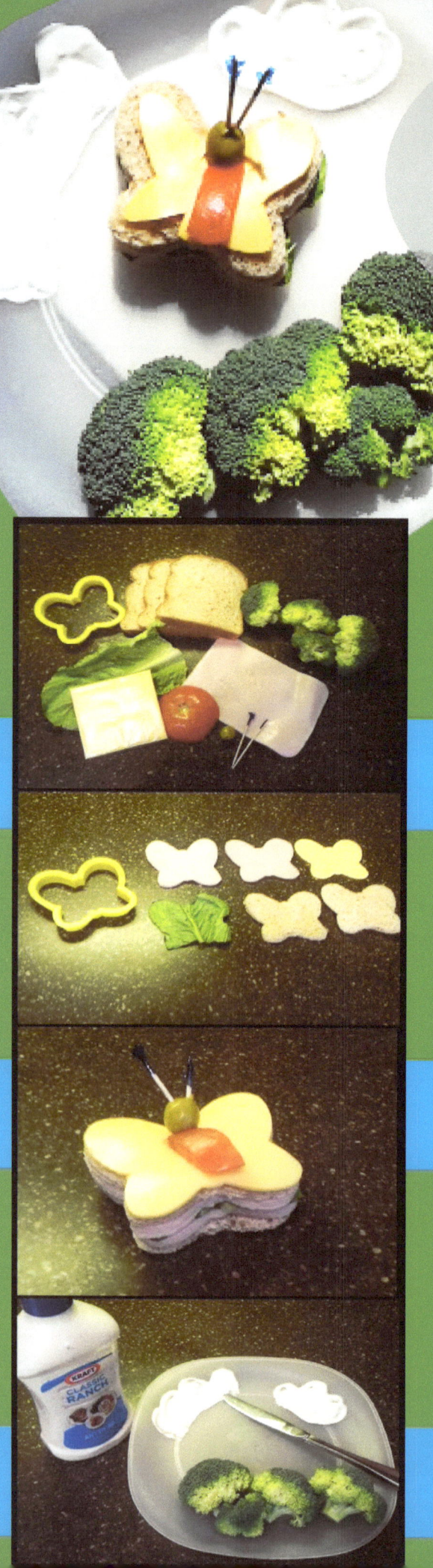

Snack Time

Kids will love to come home to these fun snacks. Mom will love how easy they are to make!

CREATED AND PHOTOGRAPHED BY MELINDA STRUSKA

Butterfly Sandwhiches

Give their after school snack wings! Create a fun spin on this healthy sanwhich option.

Serves 1
Prep time:

2-3 slices of bread
1 large piece of lettuce
3 slices lunch meat
1 tomato
1 olive
2 tooth picks
1 cheese slice
Butterfly cookie cutter
Broccoli spears
Ranch dressing

1. Using the cookie cutter, cut 6 slices of meat, 1 cheese, 1 lettuce, and 2-3 slices of bread into the butterfly shape.

2. Assemble the sandwich. Layer bread, 3 slices of meat & lettuce. Place cheese on top.

3. Slice a section of tomotoe to create the butterfly body. Place it on top of the cheese. Add the olive for the head and use the toothpicks to secure.

4. Place the broccoli on the bottom of the plate as trees. Make clouds out of ranch dressing.

VISIT MELINDA'S BLOG @ muffinsvsmuffintop.blogspot.com

Under the Sea Bagels

Inspire imagination with this healthy bagel with cream cheese snack!

Serves 1-2
Prep time: 5-10 minutes

1 Plain bagel sliced in half

2-4 tbsp. Cream Cheese

Blue food coloring

6 Swedish fish (substitute gold fish)

1. Mix 1-2 drops of food coloring with cream cheese.
2. Spread the cream cheese over bagel slices.
3. Top bagels with Swedish Fish (or Gold Fish crackers.)

ENJOY!

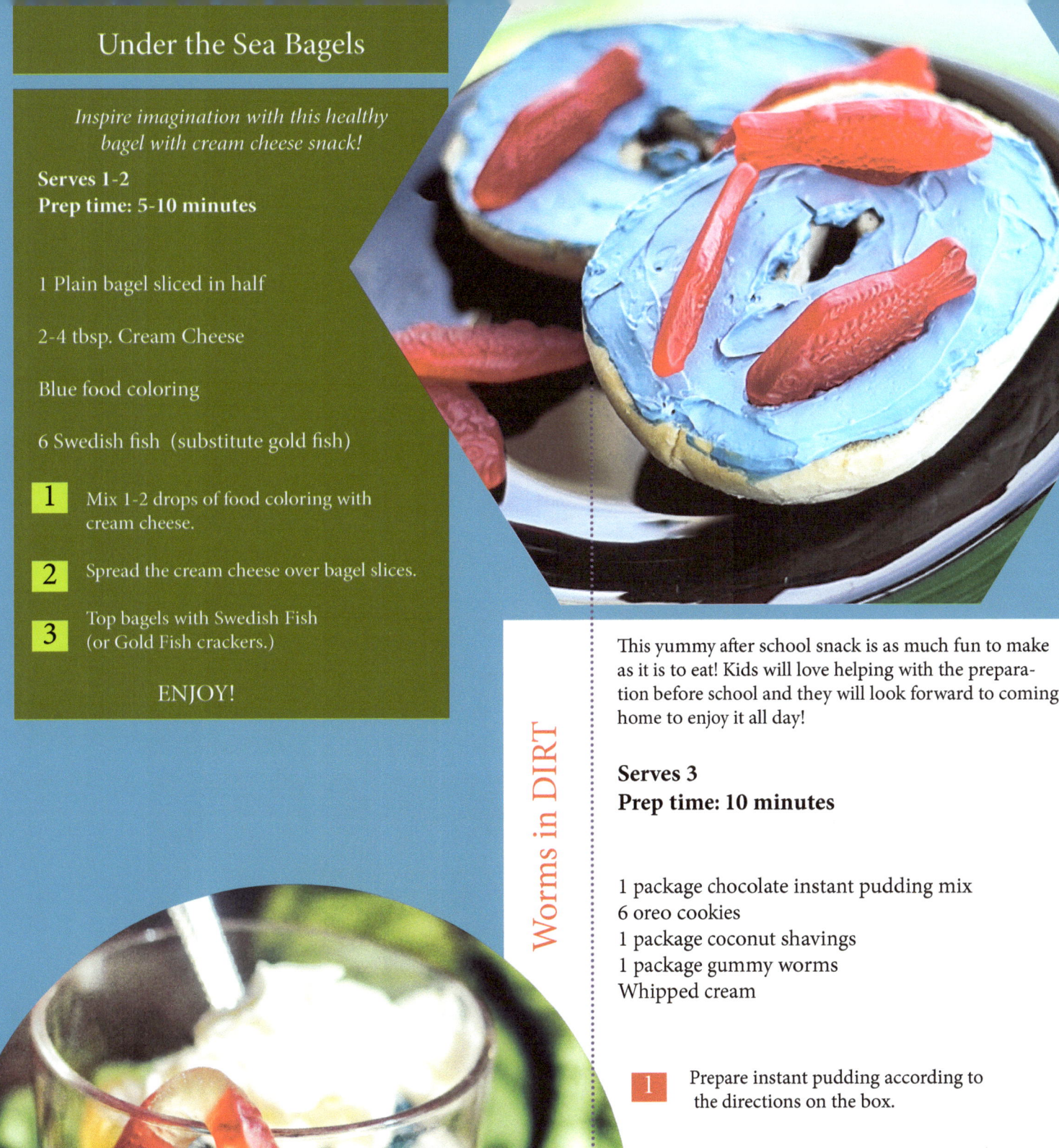

Worms in DIRT

This yummy after school snack is as much fun to make as it is to eat! Kids will love helping with the preparation before school and they will look forward to coming home to enjoy it all day!

Serves 3
Prep time: 10 minutes

1 package chocolate instant pudding mix
6 oreo cookies
1 package coconut shavings
1 package gummy worms
Whipped cream

1. Prepare instant pudding according to the directions on the box.
2. Crush oreo cookies in a plastic ziplock baggie.
3. In a clear cup layer chocolate pudding, oreos and 2 gummy worms. Repeat as desired.
4. Top with whipped cream and coconut shavings. Add 2-3 gummy worms on the top.

Eat right away or make it early and then let it chill in the fridge until after school.

Sarah Coleman

PHOTOGRAPHY BY NAOMI MAUTZ

I had the opportunity to sit down with the beautiful Sarah Coleman and pick her brain about life, love, family and her work with special needs children.

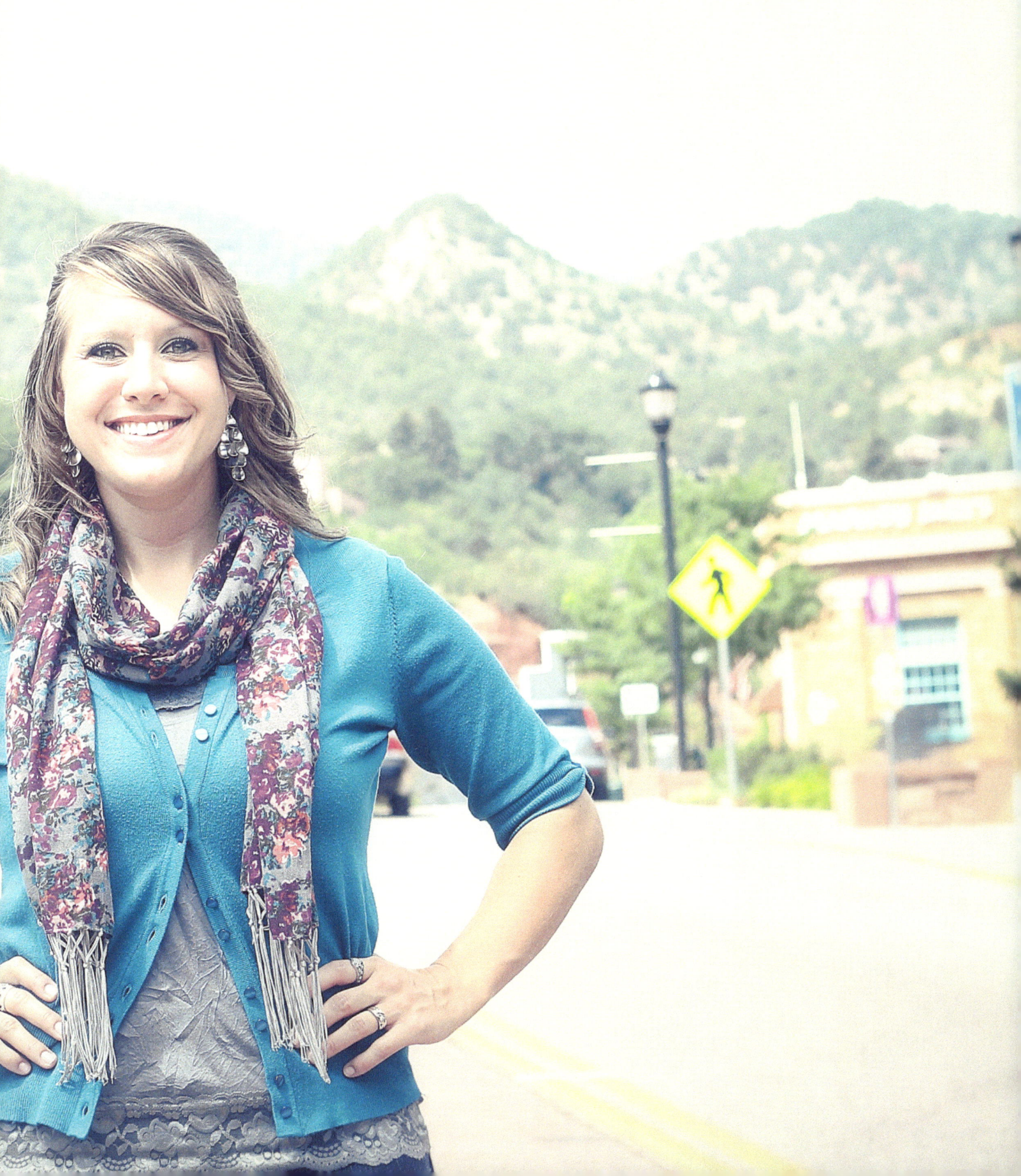

Sarah Coleman

By Naomi Mautz

With a Bachelor of Science in Missions, Psychology and Sociology, Sarah is the Autism Para at an Elementary School. She has a particular place in her heart for those with Special needs and she is currently in the process of becoming a certified foster parent. Her and her husband plan to begin the process of adopting a child with special needs.

Sarah describes herself as an avid yet inexperienced fisherwoman, an enthusiastic prankster, adventurer and instigator of water fights.

"I am an insatiable reader, a commited Denver Broncos fan and a lover of ultimate frisbee.
I love the Lord of the Rings and anything Disney.
Those closest to me would probably describe me as quiet and thoughtful but also loud and energetic. Oh, and I am pitifully lacking in culinary skills, but thankfully my husband is a great cook!"

When asked about the things she holds the most dear in life and where she finds inspiration, Sarah answered,

"God, my family and friends are my priorities. These are the things that always come first. I also love traveling, scuba diving, hiking and mountain climbing. I love sad songs and I appreciate conclusive movie endings- whether happy or sad. Acting in plays and photography are passions of mine and I am excellent at throwing a frisbee!
As far as the things that inspre me I would have to say my husband, his heart and his music. My mom is also a huge inspiration to me and she is also my best friend. I love listening to music and reading books for inspiration. I am always very moved by stories of forgiveness."

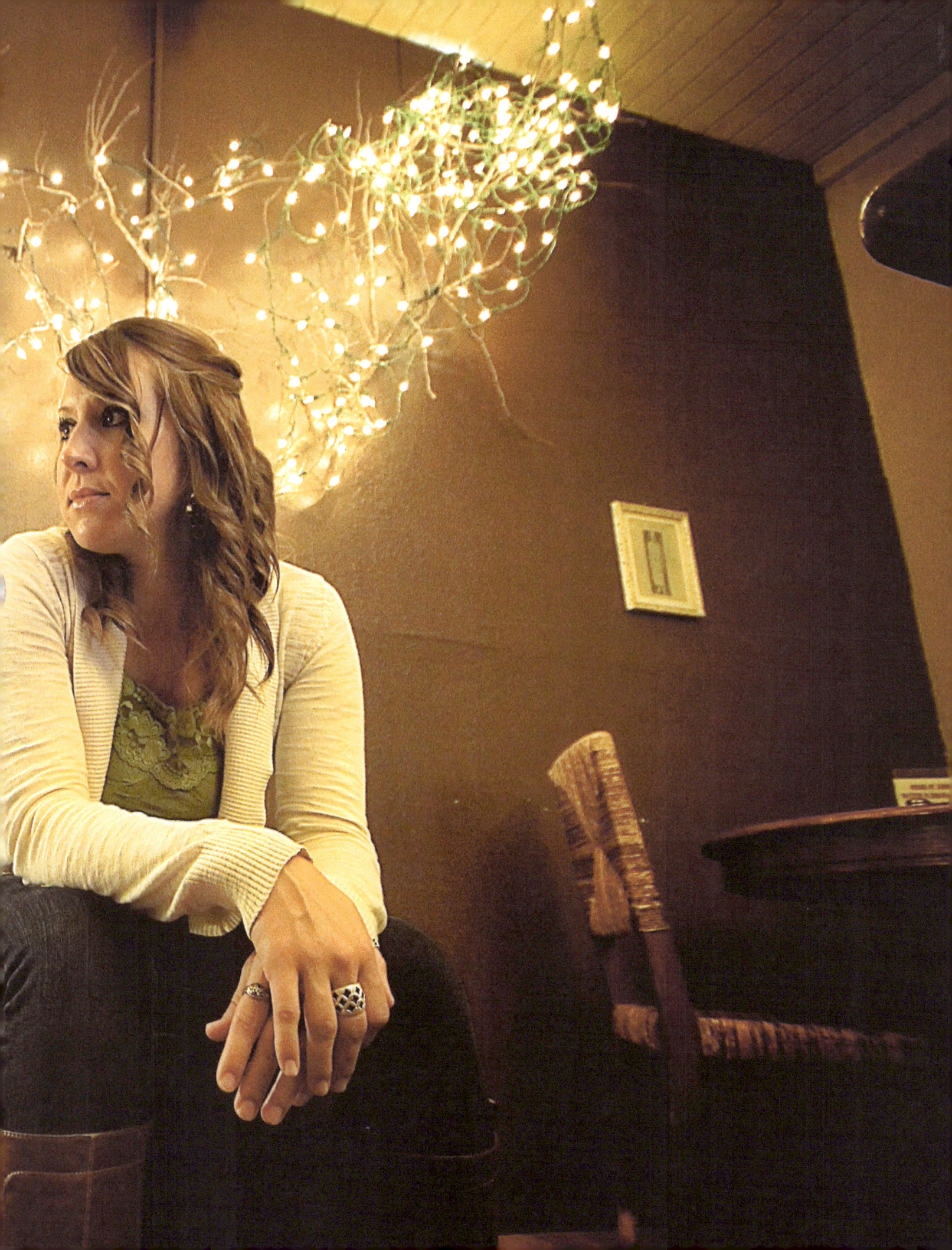

On the Cover

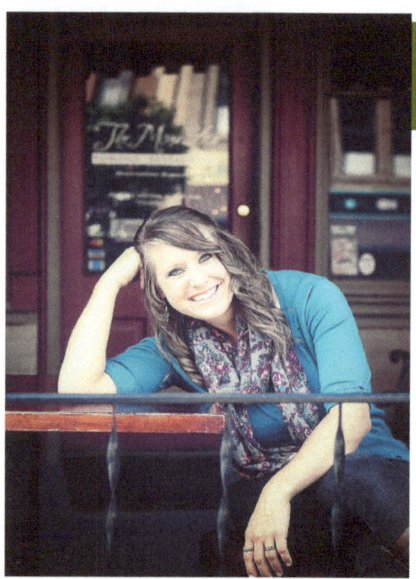

FEARS: *"I have a fear of ticks. I guess it would be better described as a slight phobia."*

PET PEEVES: *"I am not sure I have any real pet peeves, but having to cook is really annoying... I really hate cooking."*

CHARACTER DEVELOPMENT: *" I am not very comforting when people are sick. I do care and am sorry they are sick, but I'm not good at showing it. It is something I am working on."*

"As far as the things that inspre me, I would have to say my husband. His heart and his music."

SDE: *Describe the most beautiful thing about you and why it makes you beautiful.*

SARAH: I knew this question was coming ahead of time and that I wouldn't know how to answer it at all, so I asked my husband, Aaron. His response was, "The most beautiful thing to me about you is your giving spirit. Whether it is your time, your money, your gifts, or your prayers and support, you are always thinking of what you can do for others."
I guess I would agree with that.

SDE: *What are some of the inner struggles that you deal with?*

SARAH: All women tend to deal with image in some way. Like most, I struggle with worrying about my weight. Our culture seems to run on this mindset. But truly, it should not be about the scale. It's about being healthy, not super model skinny. Being healthy and strong, both mentally and physically is important to me. I participate in an awesome boot camp (through Train Fox Fitness), incorporating cardio and strength training. I also enjoy running. One of the things I love about my boot camp is the fact that we empower and encourage each other. It makes hard workouts fun! I try to see myself through God's eyes because He made me beautiful. It is then my job to take care of the body He has given me, but NOT as a slave to the scale.

SDE: *Can you tell us about a specific experience that caused you to recognize a deep, genuine beauty in yourself or someone else?*

SARAH: Reading is one of my favorite things to do, and I've always loved fiction. In grade school, my friend April and I would write the most imaginative, ridiculous stories. Our parents and awesome grade school teacher encouraged us. We interpreted it as encouragement, at least. We thought we were terribly clever, quite hilarious, and overall, we were extremely amused with our own creativity. So much confidence… It didn't matter to us if someone didn't like it, it would have been very difficult for someone to discourage us when we had so many encouragers around us. All children, whether they have a disability or not, should have that kind of love, confidence, and encouragement poured into them. Where I often see deep, genuine beauty and sincerity is in the children and adults with disabilities that I've worked with. My brother, Nathan, is my biggest example of that genuine spirit.

THE STORY OF ME
LIFE AS I KNOW IT

BY SARAH COLEMAN

My story starts with a mother committed to loving and caring for her four awesome, calm, adoring children. Well, let's be honest…we were a loud, mostly obnoxious, occasionally helpful, crazy bunch of kids, and I honestly don't know how my mother raised us on her own. She had four kids. Three boys and one girl. My brother Nathan was her first, an adorable baby boy born with Down's Syndrome. Two years later she had me, then Jon, and then Adam. I can say now that I absolutely loved having and growing up with my three brothers. Now, I know we did our fair share of fighting, as is required by such a sibling group, but we were also incredibly loyal and defensive of each other. I could not ask for better brothers or friends. My dad left us when we were young; Adam was probably just 2 or 3 years old, leaving my mom in a trail of hurts including unfaithfulness, debt, and unkind words. He still lived in town, so we would see him every once in a while, but he was rarely sober. The main things I remember are the smell of alcohol and cigarette smoke, and the consistency of broken promises. Eventually as a kid, I learned not to hope, therefore stopping any feelings of disappointment and reminders of abandonment. God was my father, and He was all I needed.

Now if there is one person that you can't get down, it is my mother. She persevered as a single mom, and with the help of my wonderful grandparents and aunt, she provided a loving, close-knit family and home. She was fully dependent on Christ, and God was her strength as she went through hardships. God always provided ways for her to take care of us.

She sent us to a Christian Elemantary school where I attended from second to sixth grade. For me, this ended up making a huge difference in shaping me into the person that I am today, particularly because of the deep and lasting friendships I made there. I'm incredibly grateful for my core group of Christian friends from grade school. We are all still close even 20 years later. Who you surround yourself with will always influence the person you are becoming. I had amazing friends.

I accepted Christ into my life at a very young age through my mom's teaching and life example. With our church family and Christian school, we grew up around loving and encouraging friends and family. But we were a unique family in our church and school because we had a brother with Downs Syndrome. If only all of you were so blessed! Some people view a disability/Down Syndrome as a sad thing. I don't mean to be insensitive to the feelings of others, but I can't even comprehend that feeling, as I've never experienced it. It only means joy to me. He makes the world a better and brighter place just by his presence. I know my younger brothers would agree that we could not imagine life without him. He is inspiring to us and to so many others without even knowing the amazing blessing he is. His smile and laughter are contagious, and his stubborn and grumpy moments are honest. Because of Nathan, I've worked with people with disabilities my entire life. I was able to volunteer in Nathan's classroom throughout Jr. High and High School, and we had a really neat school that was very loving and supportive of Nathan and all the kids in the Special Education department. One phenomenal memory I have is Nathan being voted Homecoming King our senior year. It was such a beautiful thing to see our graduating class come together in their support of him. I'll always remember hearing one of the guys running against him on the homecoming court saying, "Oh man, I don't stand a chance against Nathan."

That experience was such a blessing.

I left Wyoming to go to college in Oklahoma at Southern Nazarene University. It was difficult leaving my family. I missed them all terribly, and it was hard being gone from my two younger brothers and missing out on them finishing high school. We were all so close. My college experience was incredible though. I have so many fun memories and stories, unforgettable friends, good classes, all-nighters finishing up homework and papers, and pullingpranks when necessary.

It was also here that I met my husband, Aaron. He led worship at the church college group my friends and I attended, and we became fast friends. He is a phenomenal musician. He started playing piano when he was four, was playing Beethoven by age 8. It is his dream to conquer Rachmaninoff's 3rd Concierto. He led worship, wore Spiderman T-shirts, loved Lord of the Rings, and was very attractive. Do I know how to pick them or what? Of course, unbeknownst to him, I also had a Spiderman T-shirt! So we bonded over Jesus, our mutual admiration of Spiderman, and Lord of the Rings. We finally started dating our sophomore year. He was my first boyfriend. Whoa, huh? Lol. But true story. I can't imagine the pressure he had been under to take me on my first date! We got married the summer of 2006 after our junior year, sharing "our first" and MY first kiss on our wedding day to the song, Kiss the Girl from The Little Mermaid. Best. Wedding. Ever.

Once we were married, I began working at jobs off campus and I started working with special needs again. I worked at a neat daycare for special needs children. I also worked in a high school as a para, before we moved back to Wyoming where I had the opportunity to work with

continued on page 37

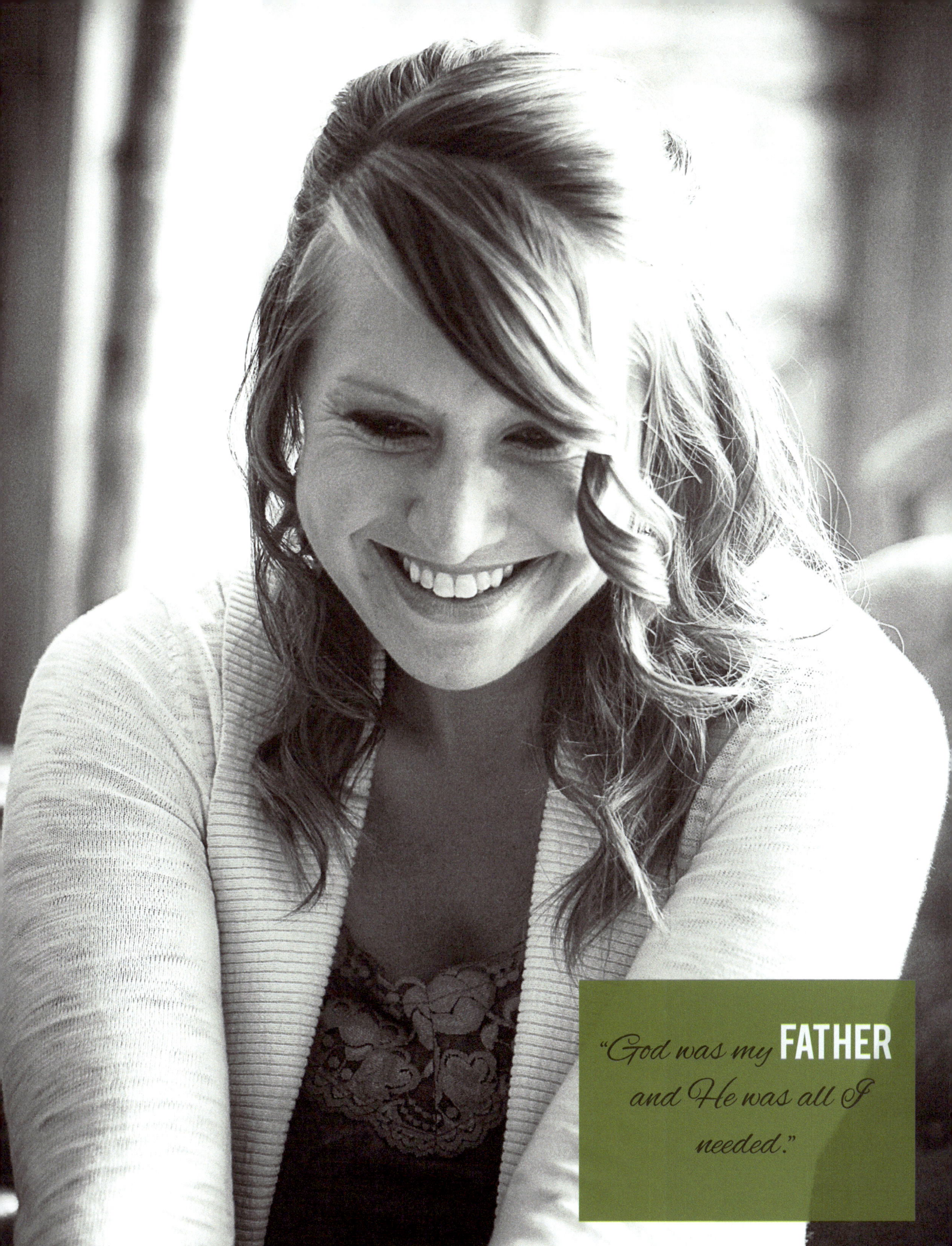

"God was my FATHER and He was all I needed."

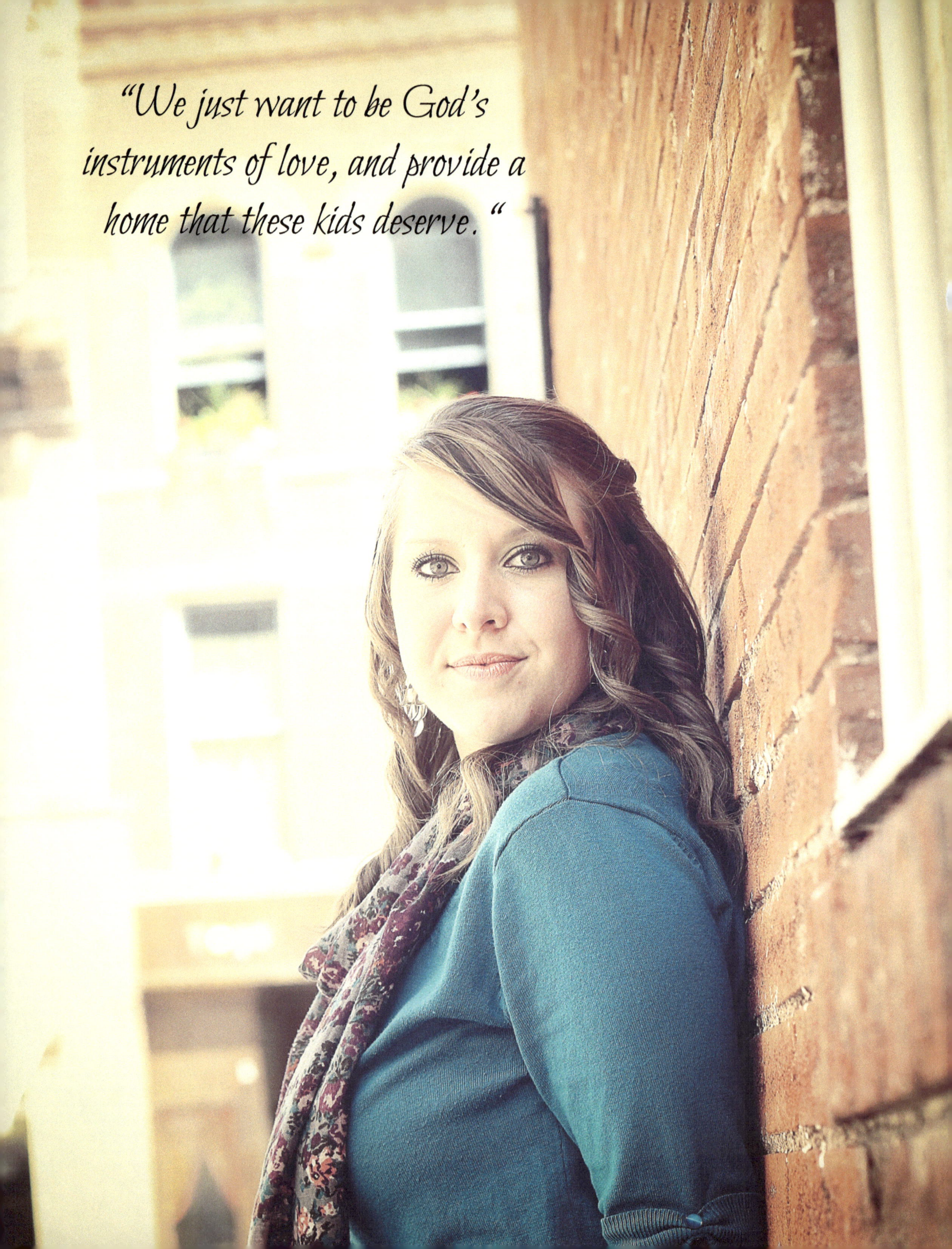
"We just want to be God's instruments of love, and provide a home that these kids deserve."

my brother and some other kids providing respite care. With Nathan we worked on creating and maintaining healthy eating and excercise habits. My mom has also been a huge influence as I have seen her love for working with children with special needs. She has two jobs: working in a school and working one-on-one as a respite provider. She, with the board, coordinates the Laramie Special Olympics program in Wyoming, and does a Bible study/social group for youth/adults with special needs. She is my inspiration. She is selfless, loyal, and passionate. Because of my brother and mom, I have volunteered with Special Olympics in WY. We also take her Bible study group up to a youth retreat and summer camp once a year. My jobs since college have all been working with Special needs, though it's not my major. I am still trying to figure out where God is leading me. I initially went to college to do Missions and Aviation. I wanted to be a missionary pilot. But they dropped the aviation program so I ended up doing Missions/Psychology/Sociology. I have been thinking about pursuing a Masters in Occupational Therapy. Much of my work history would fit into that and I could continue working with disabilities. But I'm still praying about it and trying to see God's leading since I would still love to pursue Aviation in some way.

We moved to Colorado 3 years ago, and for the last couple years I have gotten to work in an Autism classroom. It's been a great experience and I have learned so much. Every child is unique, and no matter their diagnosis or severity, they can all learn. As with Down Syndrome, there is a wide range of functioning within Autism. These students make up every level from nonverbal and working on the very basics to functioning independently in Gen. Ed. classrooms. It is so uplifting and encouraging when we can see growth, whether in academics or behaviors. There are times when we don't get the privilege of seeing a lot of academic growth in the time we have them, but we still get to plant those seeds, even if just in consistently practicing number or letter recognition. I have a neat group of teachers around me and we love to celebrate and cherish even the little goals that are met.

I have been privileged to be around special needs kids throughout my life, but my husband's story is different and fun to hear. Just to touch on it, Aaron didn't grow up around kids with special needs, not even in school. So Nathan was his first experience, and it's been a neat journey for him. We moved to Colorado because God called us here for Aaron to serve as a worship pastor at our church (Gathering Stones). He also now drives a bus for children who have special needs, has volunteered with Special Olympics, done the Buddy Walk(for Down Syndrome) multiple times, and has an amazing heart and gift for connecting with children.

Through both of our stories, God has been guiding us. We knew, even when we first got married, that God laid a calling on our hearts to adopt children with Down Syndrome. We decided that day was a long way off, so we didn't really talk about having kids or adopting for a long time. Then last December, my friend Jenna called and asked us about that "someday", and though we prayed a lot, God quickly reassured our hearts that this was His hint. So we said yes, and started the process in February. We are still in the process of being certified, but we are praying that God opens the door for whatever child or children He knows could bless us and whom we also hope to bless in return. Right now we are looking to adopt nationally, but we'd love to adopt internationally as well. There are so many Down's children in orphanages, but it is very expensive. We will have to wait and see how God is calling us. We just want to be God's instruments of love, and provide a home that these kids deserve.

We are really nervous about becoming parents in general. We would like to have our own biological children someday as well, if I can get over my irrational fears about pregnancy and child birth (haha). For now, we are happy to wait for the Lord to move. We know there are many people who surround us with prayer and we have been so blessed with such an amazing support team.

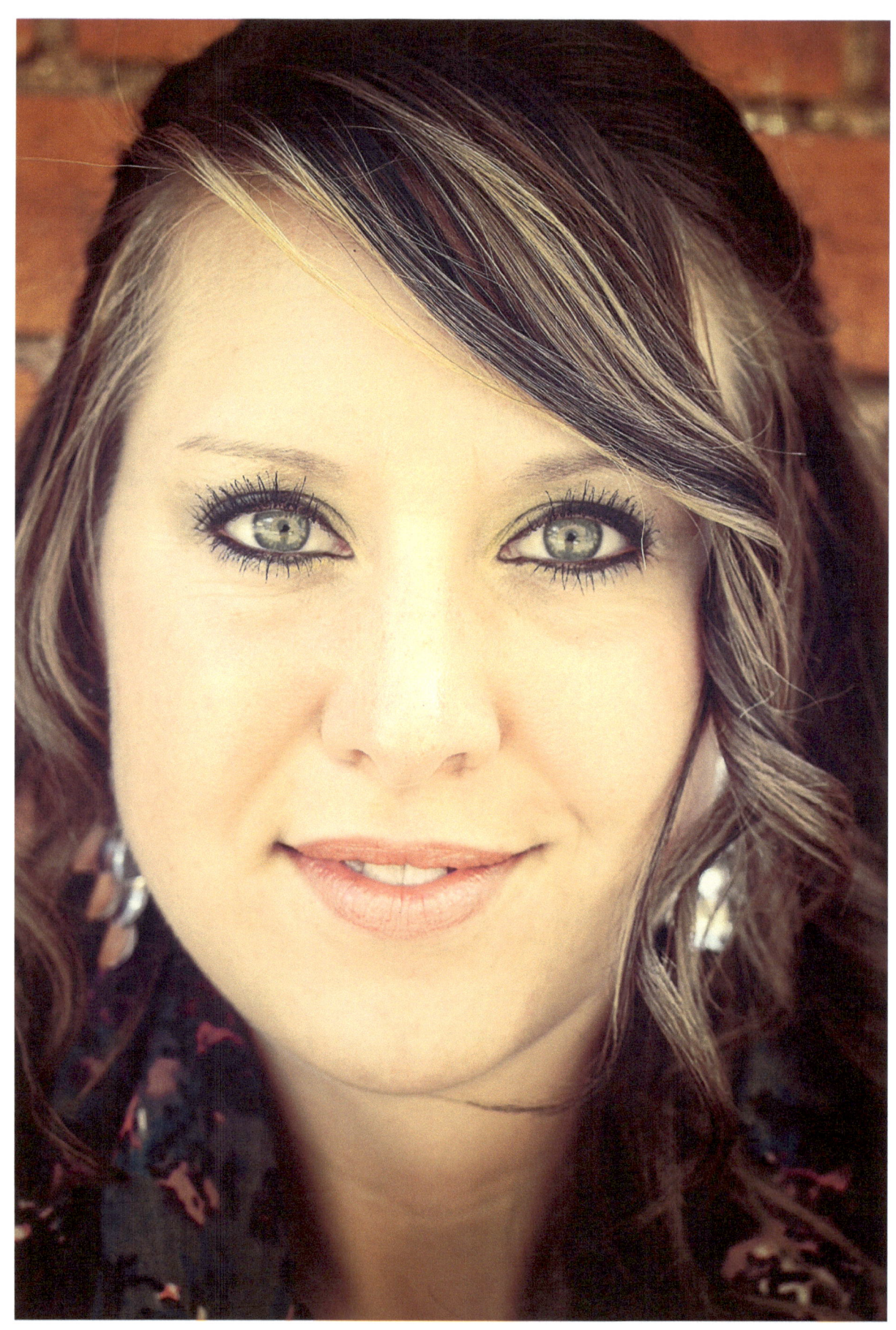

Sarah's Scrapbook

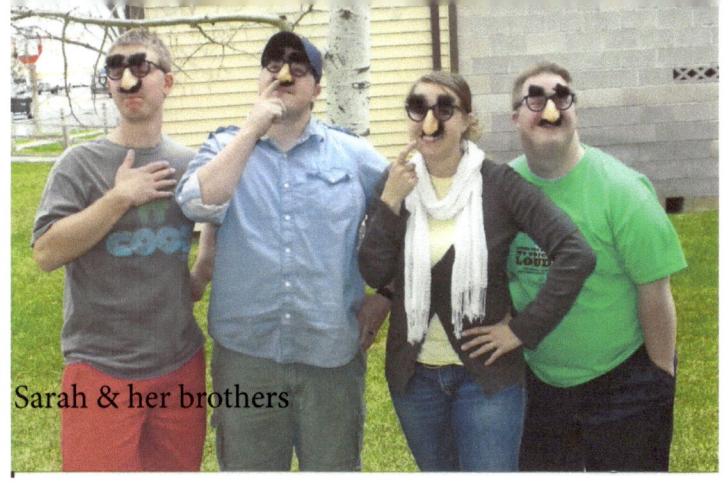
Sarah & her brothers

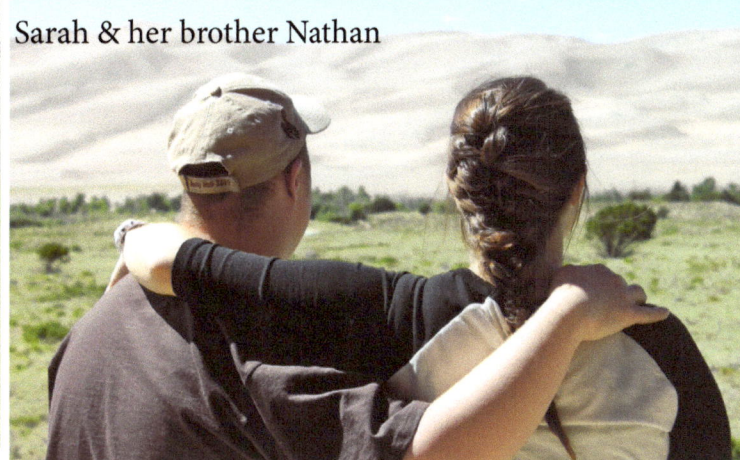
Sarah & her brother Nathan

Sarah with her mom, her brother Nathan & husband Aaron
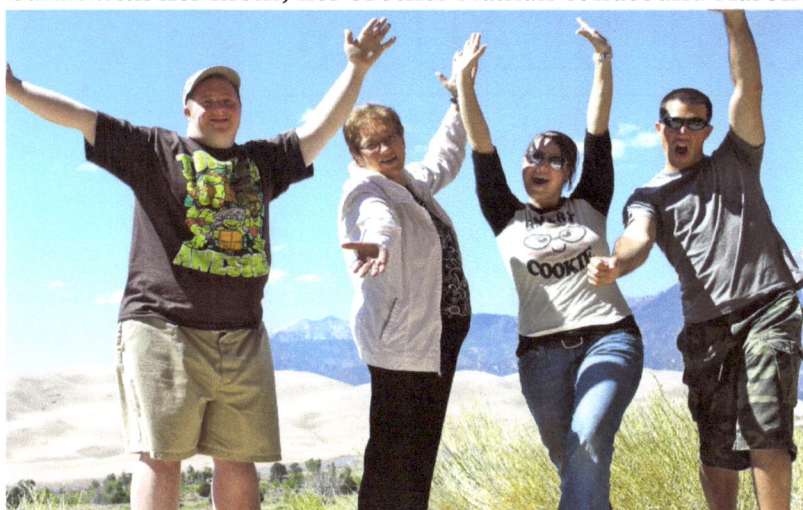

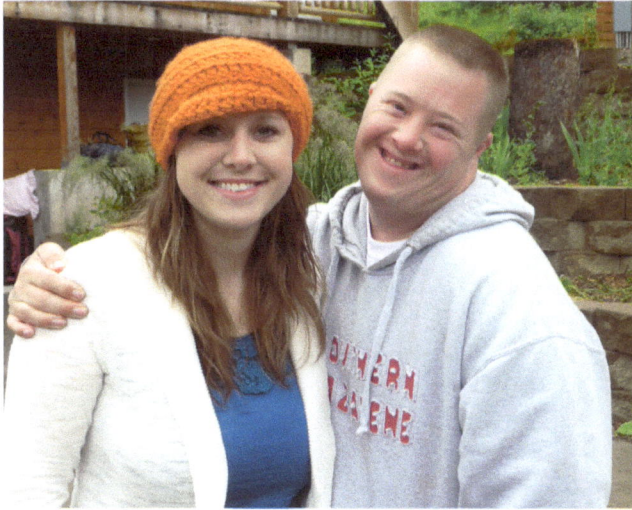

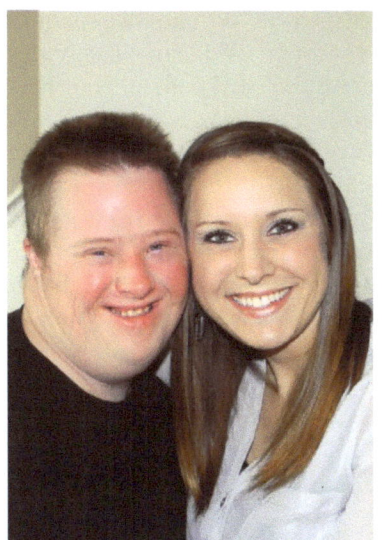

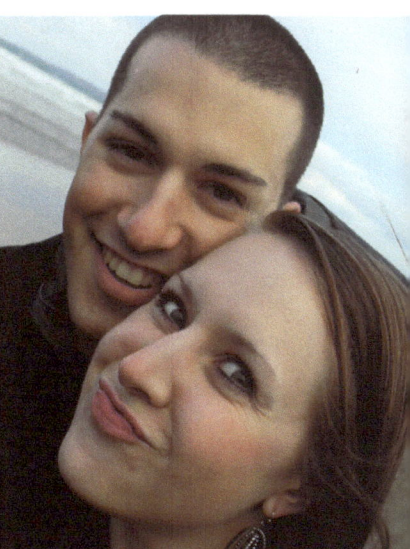

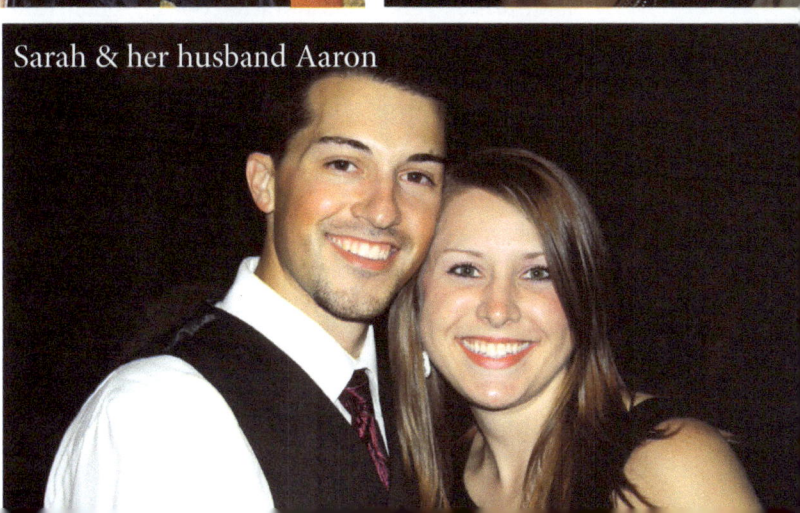
Sarah & her husband Aaron

BYGONE BEAUTY

by melinda thompson

Change is in the air. It is that time of year when everything is in transition. The seasons are beginning to change. We start looking forward to the holiday season. The kids are going back to school. Generally, our lives are in a state of chaos. If we are lucky, we manage that chaos. One of the greatest things we can come to understand is there will always be things out of our control. People are, by nature, creatures of habit and stability. We strive to make our circumstances and surroundings what we want them to be.

Whether you are preparing to send your kids back to school, going back to school yourself or were just in school once, you can appreciate the value of a school supplies list and a syllabus. These give us an outline of the supplies we need and the standards we will be expected to meet if we want to be successful. I've always felt that the Bible serves as the syllabus of life. God's word tells us what we can expect and the things we will need in order to be successful. In fact, it tells us everything we need to know. "All Scripture is God-breathed and is useful for teaching, rebuking, correcting and training in righteousness, so that the servant of God may be thoroughly equipped for every good work" 2 Timothy 3:16-17 [NIV]

Galatians 5:22-23 says, "But the fruit of the Spirit is love, joy, peace, forbearance, kindness, goodness, faithfulness, gentleness and self- control. Against such things there is no law." [NIV] This verse gives us the basics, the pencils and paper if you will. We can only control what we do and how we react. If you look at all of these Godly characteristics, they are all actions that help us deal with our circumstances. We can practice each of these traits regardless of what may be going on in our lives. We can have love for all people, no matter what they have done to us. We can have joy, peace and faith even in difficult times when we learn to be content, just as Paul says in Philippians 4:12.

I don't know about you, but I if I were able to practice continually each of the things described in Galatians, I could live a pretty happy life. The Bible gives us so much more than the basics. The Bible addresses specific struggles that we will face and gives us an example of how to live. As women, I feel that worrying is one of our biggest struggles. We have so many responsibilities and people depending on us. The passage in Matthew 6:25-31 tells us, "So do not worry about tomorrow; for tomorrow will care for itself. Each day has enough trouble of its own." We know we shouldn't worry, but how do we stop? Again, our syllabus gives us the answer. "Trust in the Lord with all your heart and lean not on your own understanding; in all your ways submit to him, and he will make your paths straight." Proverbs 3:5-6 [NIV]

Obviously, we can't even begin to scratch the surface of the advice scripture provides to help us through life. Still, as we prepare to face this season of change, I pray that we will prepare ourselves with the supplies we need and remember to consult our syllabus.

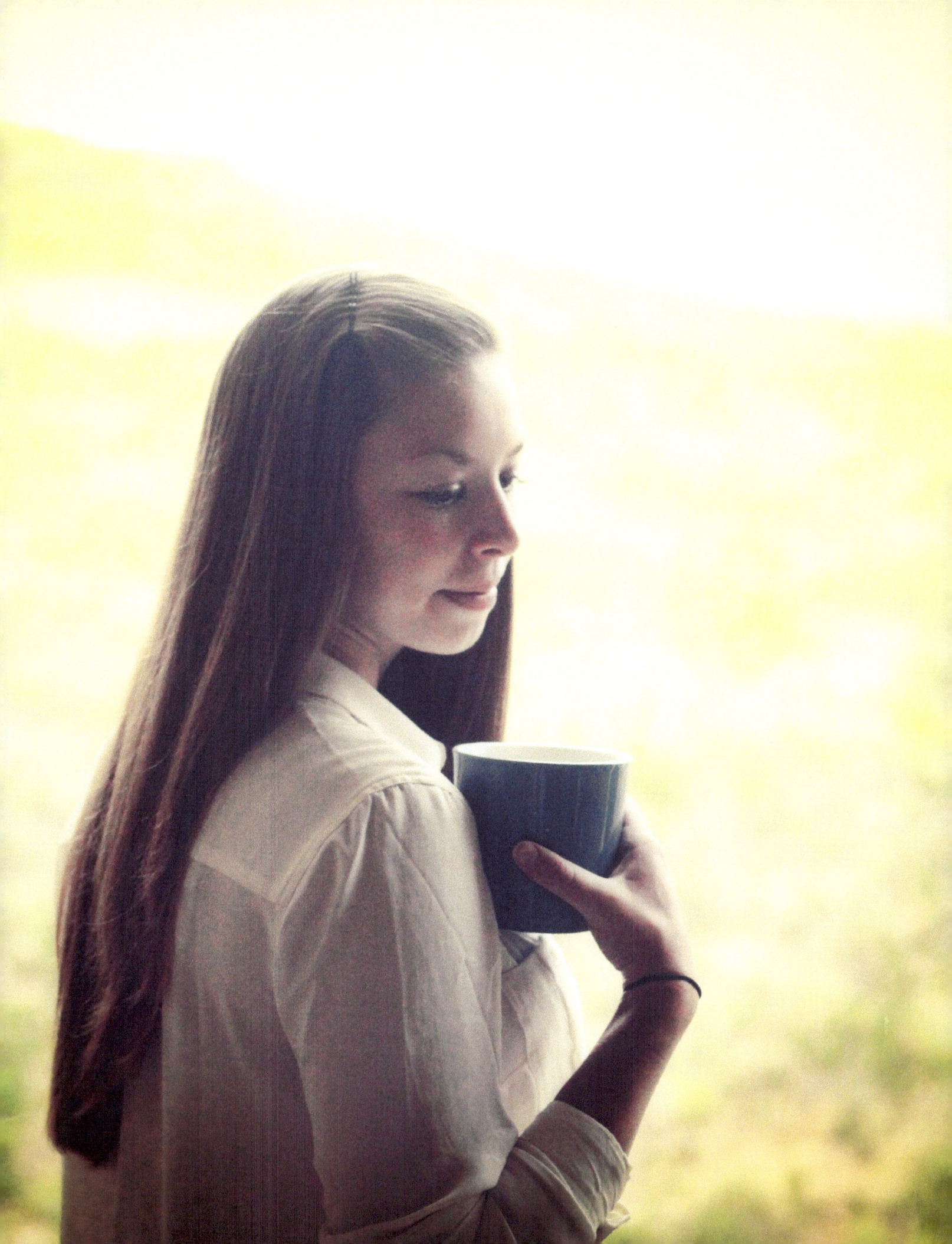

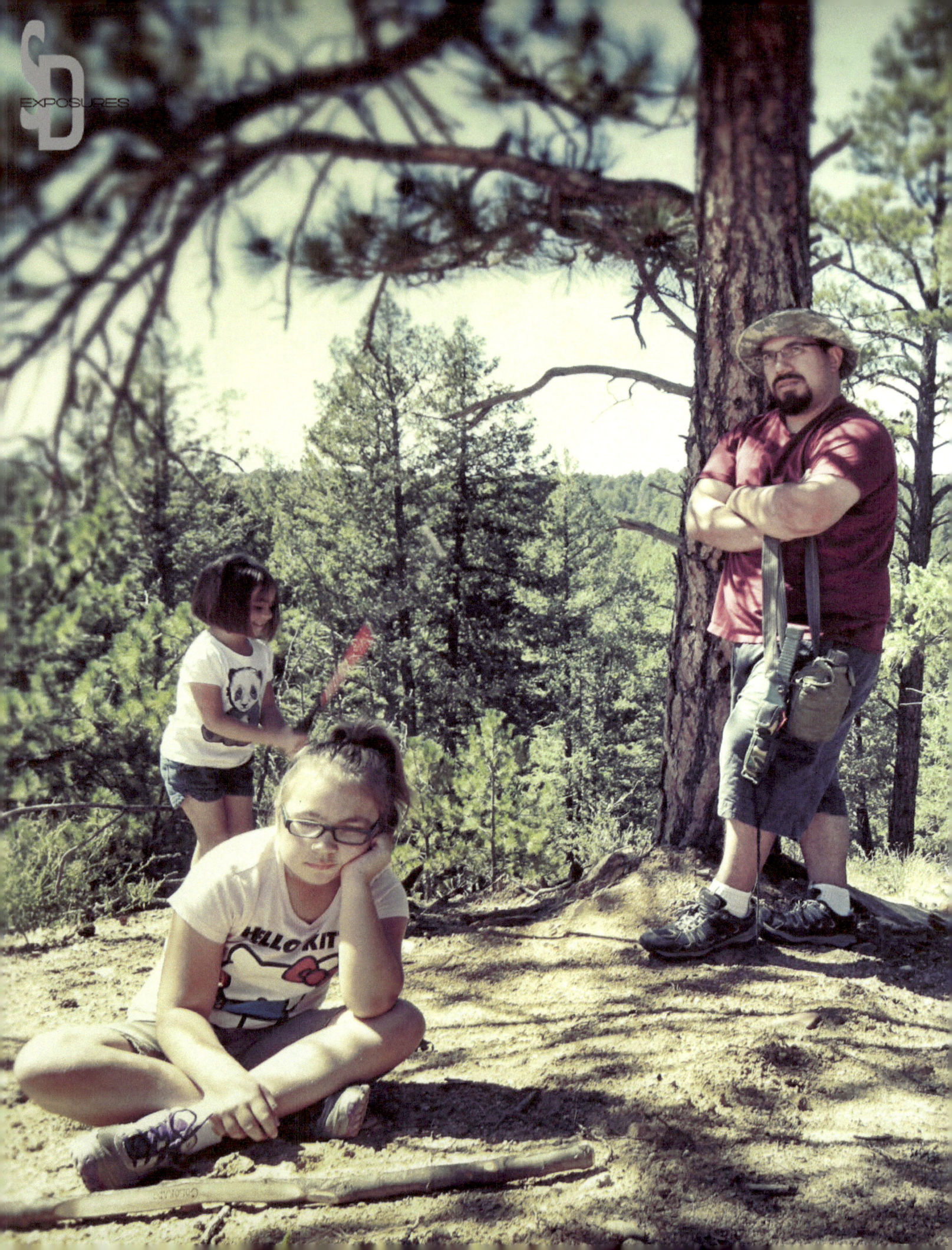

the DADDY DIARIES
by Michael Mautz

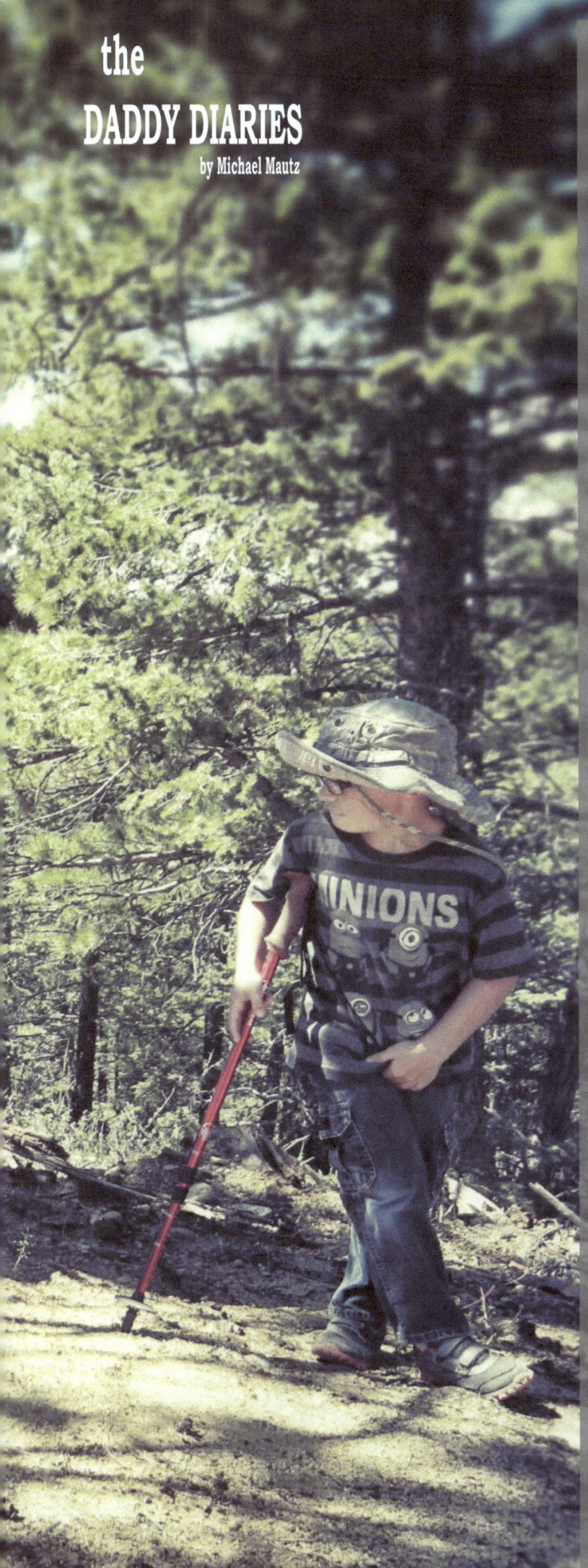

OUR HIKING mis-ADVENTURES

One of the many benefits of living out in the Forest, tucked away from much of civilization is the simple act of stepping out our back door and simultaneously stepping into the wild. That may be a bit of an overstatement but it isn't all that uncommon to see deer on the back porch, a family of turkeys cackling about or the occasional pesky skunk up to no stinking good.

One of my great pleasures is slapping a few hiking sticks in the kids' hands, tossing a water bottle in my backpack and venturing out with them into forest. We find bones, fallen antlers and the occasional petrified wood specimen that they will tuck away in their pockets.
Oddly enough, no matter how far out we walk we still find a semblance of civilization like an old beer bottle or soda can.

As a dad I get these promising ideas of how awesome these hikes are going to be. I guess deep down I am trying to recreate the same scenarios I experienced with my dad as a kid while we were out camping. Upon returning to the house with my kids, though, I am often left feeling like it was a complete failure. My ideal hiking experience with the kids is often deflated by misadventures. Those sticks I handed them for hiking turned in to nothing more than a means to bang on fallen trees and rocks. That would've been great if we were trying to make contact with that bigfoot I swear is out there.

My wife and I once got them really cheap camcorders (the $20 kind) to take on these expeditions so we could get the kids' perspective Later, after hiking for miles, someone piped up, "Daddy, did you pick up my camera?" Needless to say, we ended up doubling our mileage that day trying to find it. There was another time when we were hiking for a while and my son says, "Dad, I have to use the bathroom." I think to myself, no problem, we're in the forest, he can just duck behind a tree. Nope! Turns out "#2" was calling and we needed to hustle back up the hill which basically flushed our "adventure" down the toilette.

I have found that even though these trips never seem to go the way I envisioned them, the kids always seem to have a blast. Even when all I hear is, "Dad, I'm so tired" the entire time, they will usually say how much fun they had. I don't know if I was the cause of any frustration for my dad on our treks together but I do know that I had a wonderful time just being outdoors with him. I can only hope that the same is true with my own kids. I can honestly say that I sure enjoy that time with them. And who knows, the day may yet come when my kids get to watch me catch a piggieback ride from that evasive sasquatch!

TRAIN FOR A 5K

Getting Started

Watch Your Form

30 Day Training Calendar

BY MELINDA STRUSKA

Getting Started

CONGRATULATIONS!

You have signed up for a 5k, paid the entrance fee and commited to a date...

So, now what? How do you train? What do you need to know to get ready for your race? Sometimes signing up is the easiest part. It is the time leading up to the actual race that can be both exciting and overwhelming; especially if this is your first 5k. I recommend giving yourself at least 30 days to prepare both mentally and physically.

I have created an easy workout plan designed to take you from couch potatoe to 5k diva in 30 days. So if you are serious about your commitment, then I am serious about getting you to the starting line, confident and ready.

Begin your training by doing a little bit of important prep work:

- *Now that you have signed on the dotted line, post your goals on Facebook or another form of social media. This will give you extra motivation and you can request that others hold you accountable for your training workouts. Accountability is huge with any commitment, the more people who know your intentions, the less likely you are to throw in the towel.*

- *The next very important step is to invest in a pair of sturdy running shoes. You will notice the difference between cheap tennis shoes and quality running shoes. Sometimes people lose out on the joys of running simply because they have been attempting to run in the wrong shoes their whole lives. Shoes that have not been designed for the runner will often feel like you are running on a cement board. They will not absorb any of the shock that quality running shoes are designed to absorb, leaving your joints feeling achy and sore. Visit your local running store and utilize the help of a professional. They will ask you what type of exercise you will be doing and then have you preform that excercise on a high tech treadmill that will gague your strut, balance and arch as well as many other diagnostics. This will help them find the correct fit and support for you and your feet, making running and even walking a much more pleasant experience. A pair of running shoes is a wonderful and highly recommended investment.*

- *Before you start training for your race, figure out where you will be training. Will you be using a treadmil at home? Do you need to get a gym membership or will you be running outside? If you are using a treadmill remember to start out slowly and run in the center of the belt. If you are running outside, remember safety. Run against oncoming traffic, wear reflective clothing and always be aware of your surroundings.*

Now it is time to break in those new running shoes. When running, remember to practice proper form, and keep an eye on your heart rate. Maintaining the correct form will help keep your energy level up so you do not tire as easily. Proper form also protects your joints and muscles from fatigue as well as from absorbing unecessary shock.

- *Take short quick strides.*

- *Aim for 180 steps per minute.*

- *Take deep breaths in through the nose and out of the mouth.*

- *To test your breathing, try talking or singing while jogging. (you should be able to maintain a conversation at all times during your workouts.)*

- *If you find that your breathing has become too labored to maintain conversation, slow down until you are able to converse. If you find that your breath is not labored at all, pick up your speed until you are breathing comfortably hard.*

- *Try to run either in the morning or at sunset and not during the hottest part of the day in order to conserve energy and prevent dehydration.*

- *Drink plenty of water, before after and during your workouts. Dehydration can cause a whole host of problems including exhaustion, cramps and pulled muscles as well as several more serious health issues. So keep drinking.*

- *Make sure you always cool down and stretch after every workout to keep your muscles limber and prevent pulling and stiffness.*

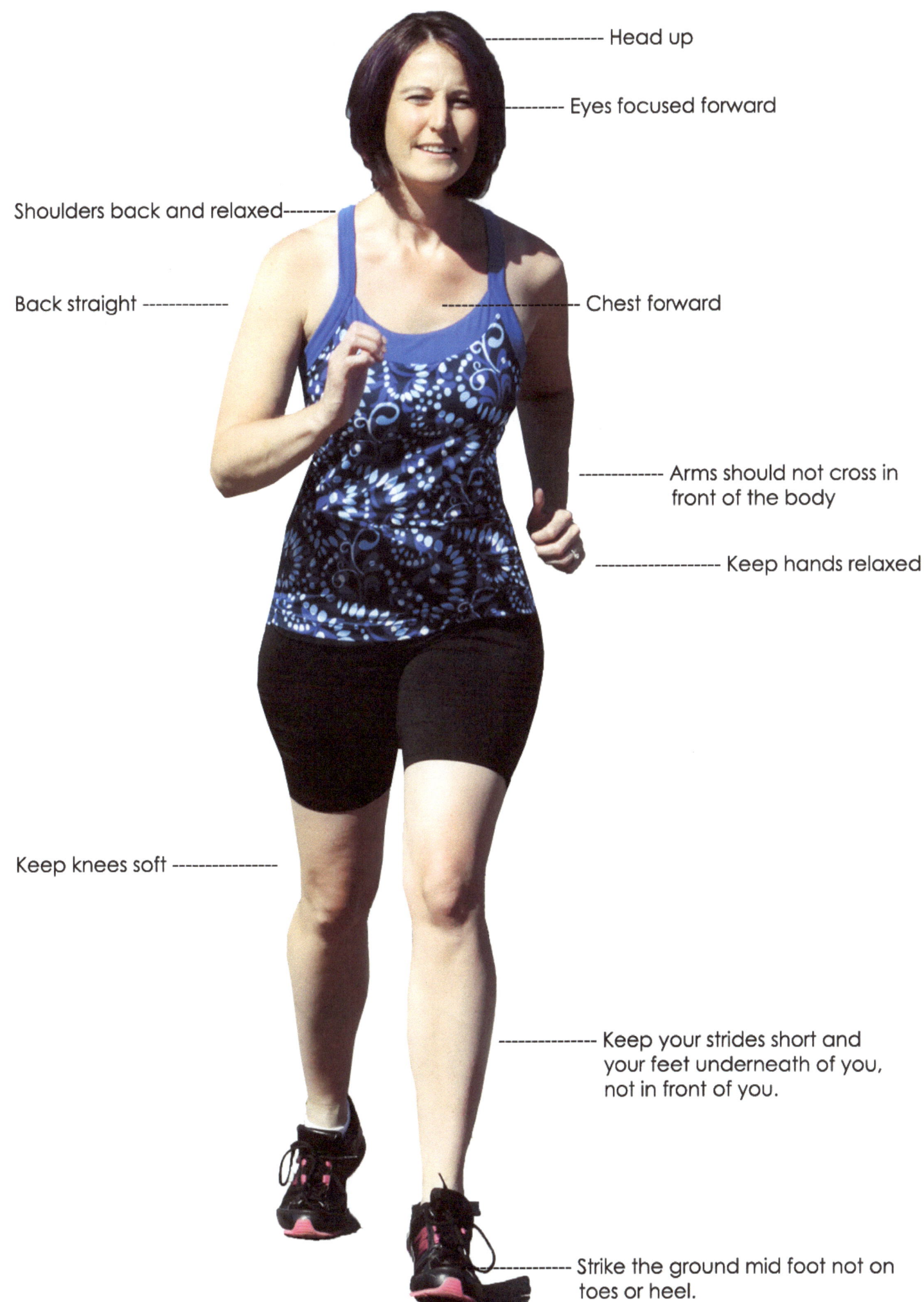

Train for your 5K in 30 Days

Day 1 Walk 10 minutes @ 2 mph Do interval training: Jog 30 sec. @ 3 mph walk 1 min. @ 2 mph (8x)	**Day 2** Walk 15 minutes @ 2 mph (Focus on proper form) Walk 30 minutes @ 2 mph	**Day 3** Walk 15 minutes @ 2 mph Do interval training: Jog 1 min. @ 3 mph walk 1 min. @ 2 mph (8x)	**Day 4** Walk 20 minutes @ 2 mph REST	**Day 5** Walk 20 minutes @ 2 mph Do interval training: Jog 2 min. @ 3 mph walk 1 min. @ 2 mph (7x)	**Day 6** Walk 25 minutes @ 2 mph Walk 30 minutes @ 2.5 mph	**Day 7** REST REST
Day 8 Walk 30 minutes @ 2.5 mph Do interval training: Jog 2 min. @ 3.5 mph walk 1 min. @ 2 mph (7x)	**Day 9** Walk 30 minutes @ 2.5 mph (Focus on breathing) Walk 30 minutes @ 3 mph	**Day 10** Walk 30 minutes @ 2.5 mph Do interval training: Jog 4 min. @ 3.5 mph walk 1 min. @ 2 mph (6x)	**Day 11** Walk 35 minutes @ 2.5 mph (increase incline) REST	**Day 12** Walk 35 minutes @ 2.5 mph (w/ increased incline) Do interval training: Jog 6 min. @ 3.5 mph walk 1 min. @ 2 mph (6x)	**Day 13** Walk 35 minutes @ 2.5 mph (w/ increased incline) Walk 30 minutes @ 3 mph	**Day 14** REST REST
Day 15 Walk 40 minutes @ 2.5 mph Do interval training: Jog 9 min. @ 4.0 mph walk 1 min. @ 2.5 mph (4x)	**Day 16** Walk 40 minutes @ 2.5 mph (Focus on arm motion to add speed.) Walk 45 minutes @ 3 mph	**Day 17** Walk 40 minutes @ 2.5 mph Do interval training: Jog 12 min. @ 4.0 mph walk 1 min. @ 2.5 mph (3x)	**Day 18** Walk 45 min. @ 5 min. interval speed. (switch off: 5 min. @ 3 mph, 5 min. @ 2 mph) REST	**Day 19** Walk 45 min. @ 5 min. interval speed. Do interval training: Jog 15 min. @ 4.0 mph walk 2 min. @ 2.5 mph (3x)	**Day 20** Walk 45 min. @ 5 min. interval speed. Walk 45 minutes @ 3 mph	**Day 21** REST REST
Day 22 Walk 50 min. @ 3 mph Do interval training: Jog 20 min. @ 4.0 mph walk 1 min. @ 3 mph (2x)	**Day 23** REST Walk 30 minutes @ 3 mph	**Day 24** Walk 50 min. @ 3 mph Do interval training: Jog 25 min. @ 4.0 mph walk 1 min. @ 3 mph (1x)	**Day 25** REST REST	**Day 26** Walk 50 min. @ 3 mph Do interval training: Jog 40 min. @ 4.0 mph walk 1 min. @ 3 mph (1x)	**Day 27** REST Walk 40 minutes @ 3 mph	**Day 28** Walk 50 min. @ 3 mph Do interval training: Jog 40 min. @ 4.0 mph walk 1 min. @ 3 mph (1x)
Day 29 REST REST	**Day 30** RACE DAY! RACE DAY!	Follow the BLUE plan	If you are planning to *WALK* your 5K.			
		Follow the GREEN plan	If you are planning to *RUN* your 5K.			

FALL FAVORITES
By Wendy Carns and Shelly McCaleb

The Krafty Kitchen

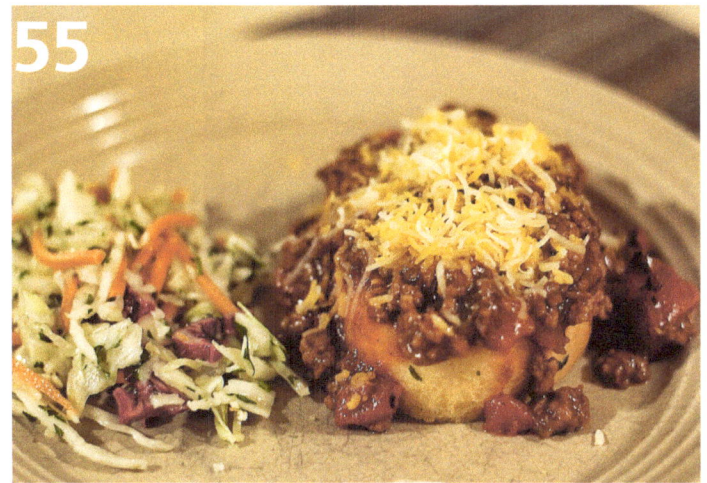
55

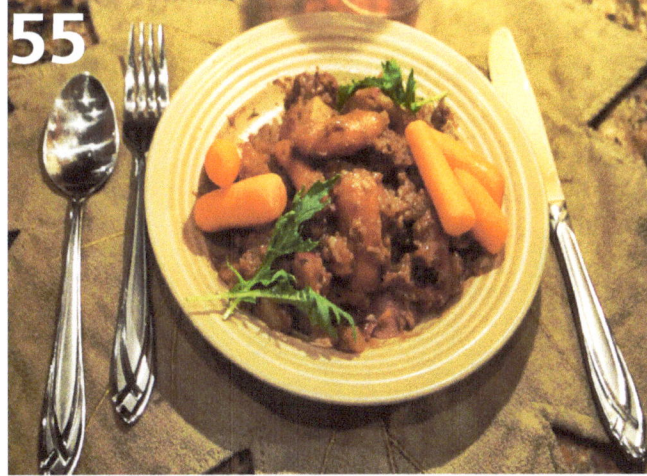
55

56

53

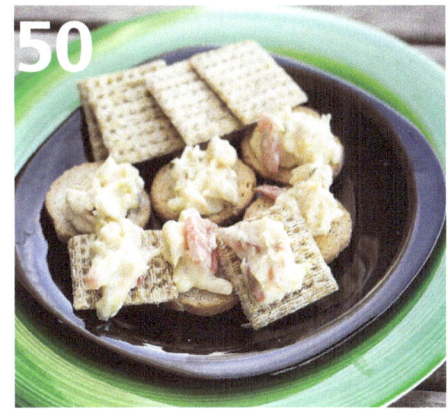
50

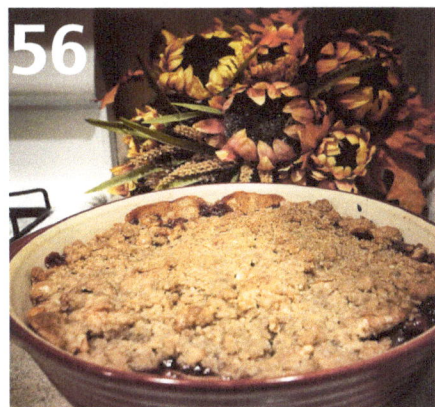
56

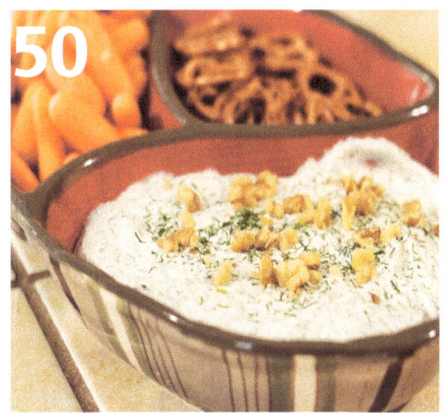
50

FINGER FOODS
[50]

Chicken Salad Bites

Yogurt, Dill & Walnut Dip

MAIN DISHES
[55]

Old Tyme Beef Stew

Cheesy BBQ Sloppy Joe's

SIDE DISHES
[53]

Quinoa Walnut Salad

Mexican Cole Slaw

Potato & Bacon Soup

DESSERTS
[56]

Autumn Apple Crisp

Iced Pumpkin Cookies

Chicken Salad Bites

4 cups cooked chicken, shredded or cubed. (To keep things easy I bought a rotisserie chicken)
3 tablespoons chopped onion
1/3 cup chopped carrots
1/3 cup chopped celery
1 cup light mayo
2 tsp dijon mustard
juice of one lemon
1 tsp salt
1 tsp pepper
1/2 tsp garlic powder

Throw everything in a large bowl and mix well. Refrigerate and serve.

Submitted by MeLinda Struska

Yogurt, Dill and Walnut Dip

2 cups Greek yogurt
1 clove garlic (chopped)
¼ cup chopped walnuts (+ 2 tbsp extra for garnish)
¼ cup chopped dill (+1 tsp extra for garnish)
½ tsp Kosher salt

Combine all ingredients (except for the extra for garnish) and refrigerate for at least 2 hours. When ready to serve garnish with extra dill and walnuts.

Serve with carrots, celery, tomatoes and blanched green beans.

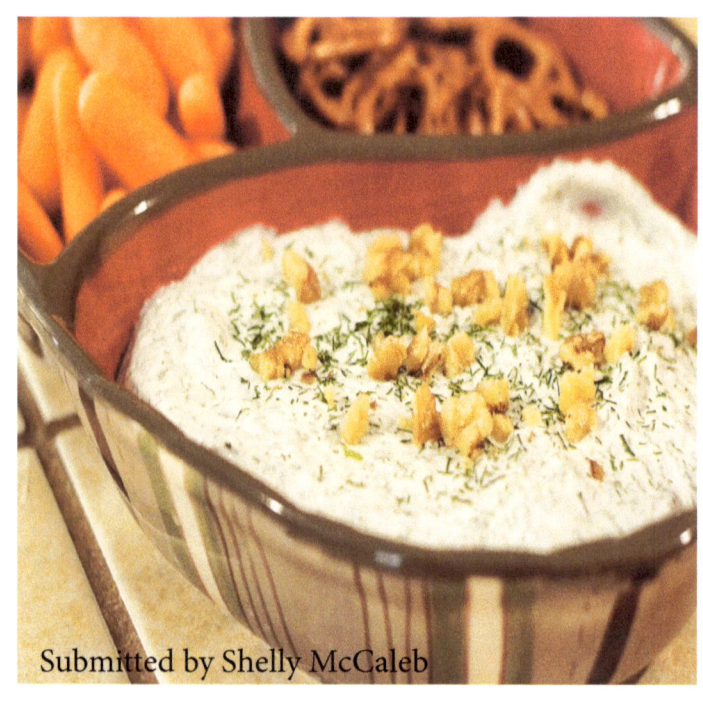

Submitted by Shelly McCaleb

Finger foods

Side dishes

Quinoa Walnut Salad

1 cup mixed quinoa
2 cups water (for cooking quinoa)
1 cup lentil sprouts (optional)
1/2 package frozen mango (thawed OR 1-2 diced fresh mango)
1/4 large red onion, diced
1/2 medium to large red pepper, diced
1/2 small bunch cilantro, chopped
1 cup shredded, unsweetened coconut (optional)
1/3 cup unsalted, dry-toasted slivered almonds
3/4 cup raisins or cranberries
1 1/2 cups frozen edamame, thawed
Juice of 2-3 limes
2-3 Tbsp Balsamic Vinegar

1. Rinse quinoa well, cook as directed.
2. Fluff quinoa well when done, spread out and let cool.
3. Add all other ingredients and toss.
4. Enjoy cold.

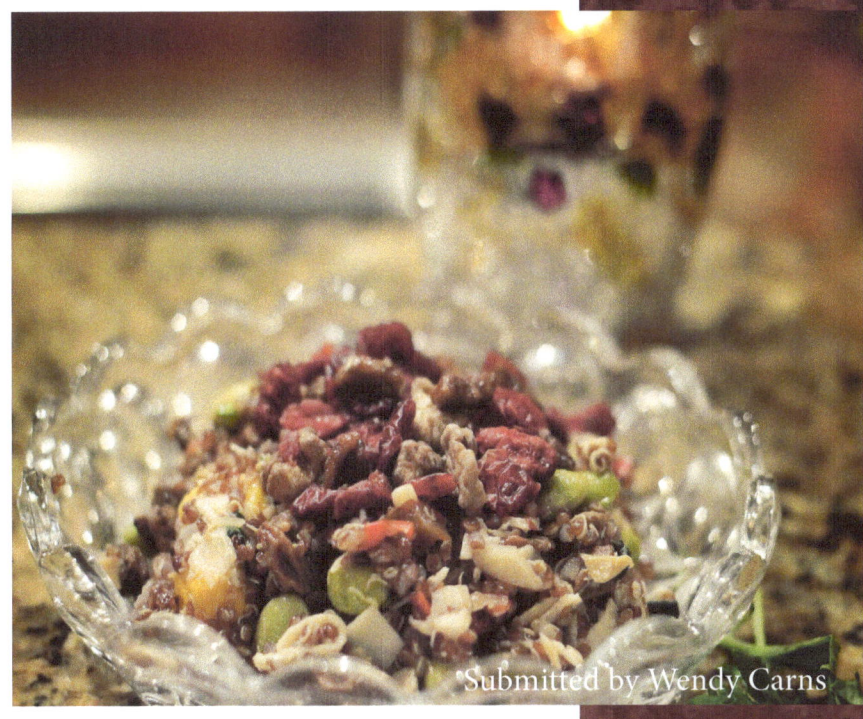
Submitted by Wendy Carns

Mexican Coleslaw

6 cups thinly sliced green cabbage (about ½ head or 1 package coleslaw mix)
1 ½ cups peeled and grated carrots (2-3 medium)
1/3 cup chopped cilantro
¼ cup rice vinegar
2 tbsp extra-virgin olive oil
¼ tsp salt

Place cabbage and carrots in colander, rinse thoroughly and drain to crisp. Let drain for 5 minutes. Meanwhile, whisk cilantro, vinegar, oil and salt in a large bowl. Add cabbage and carrots. Toss well to coat.

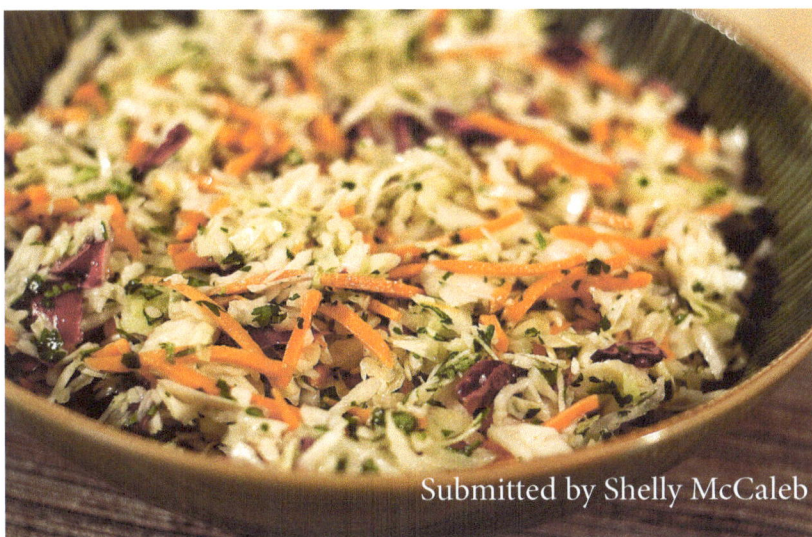
Submitted by Shelly McCaleb

Potato and Bacon Soup

6 slices of bacon chopped into bite size pieces
2 medium onions diced
4 cups potatoes cubed
1 cup water
1 tsp salt
1/8 tsp pepper
1 can Cream of Chicken soup
1 cup sour cream
1 ½ cup milk

Saute onions and bacon until bacon is cooked and onions are translucent. Drain bacon grease.
In a large stockpot add potatoes, water, milk, sour cream, Cream of Chicken soup, sauteed onions and bacon, salt and pepper. Cook on medium/high heat until boiling (stir continuously to keep from sticking). Once boiling reduce heat to low and simmer for about 20 minutes. Stir occasionally. Serve and garnish with cheddar cheese.

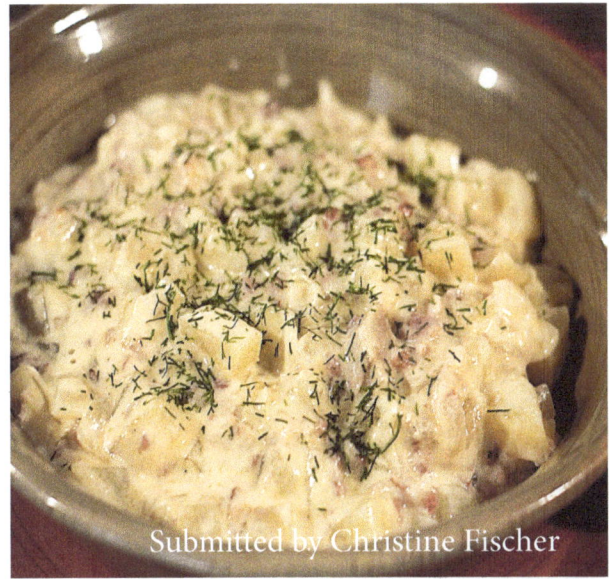
Submitted by Christine Fischer

Main dishes

Old Thyme Beef Stew

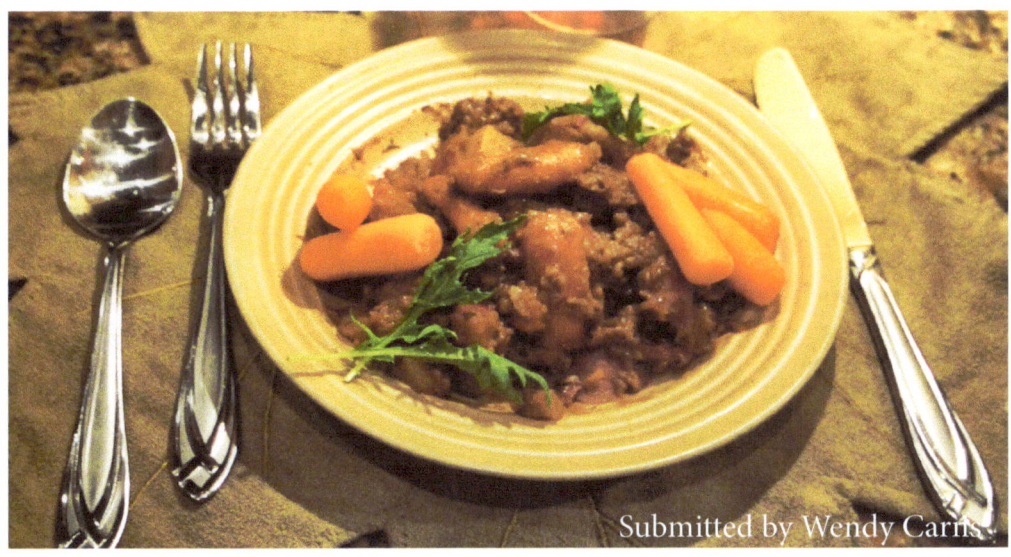

3 lbs boneless chuck roast, cut into 2-inch pieces
3 tbsp vegetable oil
2 tsp salt
1 tbsp freshly ground pepper
2 yellow onions, cut into 1-inch chunks
1/4 cup flour
3 cloves garlic, minced
1 cup red wine
3 cups beef broth
1/2 tsp dried rosemary
1 bay leaf
1/2 tsp dried thyme
4 carrots, peeled, cut into 1-inch slices
2 stalks celery, cut into 1-inch slices
3 large russet potatoes, peeled and cut in eighths
fresh parsley to garnish (optional)

Submitted by Wendy Carns

1. On medium-high heat, add the vegetable oil to a large heavy pot (one that has a tight fitting lid).
2. When it begins to smoke slightly, add the beef and brown very well. Do in batches if necessary. Add the salt and pepper as the beef browns.
3. Once browned, remove the beef with a slotted spoon set aside.
4. Add the onions and sauté for about 5 minutes, until softened.
5. Reduce heat to medium-low, and add the flour and cook for 2 minutes stirring often.
6. Add the garlic and cook for 1 minute.
7. Add wine and deglaze the pan, scraping any brown bits stuck to the bottom of the pan. The flour will start to thicken the wine as it comes to a simmer.
8. Simmer wine for 5 minutes, and then add the broth, bay leaves, thyme, rosemary, and the beef.
9. Bring back to a gentle simmer, cover and cook on very low for about 1 hour.
10. Add potatoes, carrots, and celery, and simmer covered for another 30 minutes or until the meat and vegetables are tender. Taste and adjust seasoning.
11. Turn off heat and let sit for 15 minutes before serving. Garnish with the fresh parsley if desired.

Cheesy BBQ Sloppy Joe's

1 ½ lbs hamburger
1 can diced tomatoes (14.5 ozs)
1 cup ketchup
½ cup BBQ sauce (your choice)
1 tbsp Worcestershire sauce
2 tbsp pickled jalapenos (chopped)
1 tbsp jalapeno juice
frozen garlic toast
½ cup shredded sharp cheddar cheese

Brown ground beef and drain off fat. Stir in tomatoes, ketchup and BBQ sauce, jalapeno's, juice and Worcestershire sauce. Cover and cook on medium heat for about 10-15 minutes.

Cook garlic toast according to package instructions. Serve beef over toast and top with cheese.

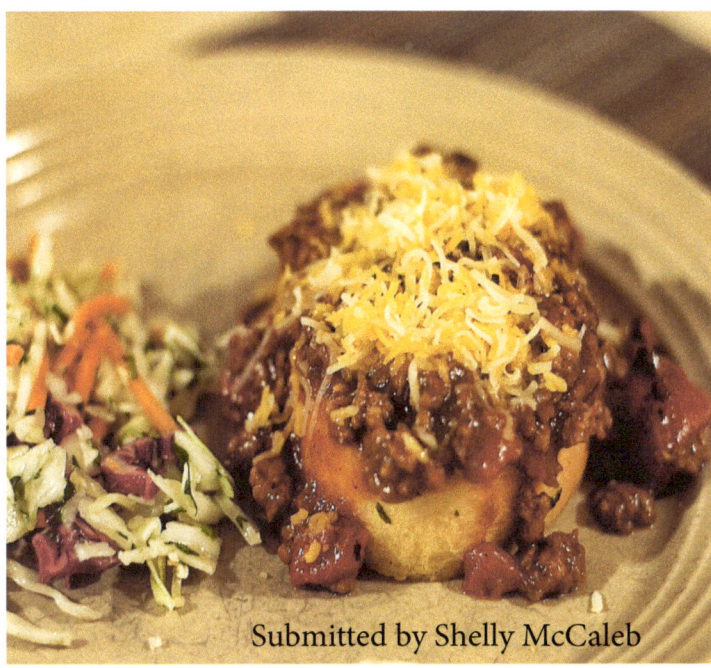

Submitted by Shelly McCaleb

Autumn Apple Crisp

Ingredients:
2/3 cup all-purpose flour
3/4 cup packed brown sugar
1/4 cup chopped pecans or walnuts
1/4 teaspoon salt
1/2 teaspoon nutmeg
1/2 teaspoon cimmamon
6 tablespoons butter
5-6 large apples, peeled and chopped
2 tablespoons packed brown sugar
1 tablesppon lemon juice
1 teaspoon cinnamon

Instructions:
1. Whisk the flour, 3/4 cup brown sugar, pecans, salt, nutmeg and 1/2 teaspoon cinnamon in large mixing bowl.
2. Add butter and beat until mixture is coarse and crumbly.
3. Place apples into a baking dish and add 2 tablespoons brown sugar, lemon juice and 1 teaspoon cinnamon and toss gently to coat apples.
4. Cover the apples with the crumb mixture.
5. PLace on a baking sheet to catch any drips.
6. Bake on the middle rack in a preheated oven at 375 degrees for 30 to 45 minutes or until apples are tender, the juices are bubbling and the top is golden brown.

Once cooled the crisp can be covered and stored at room temp for up to 2 days. The crisp is good warm or cold.

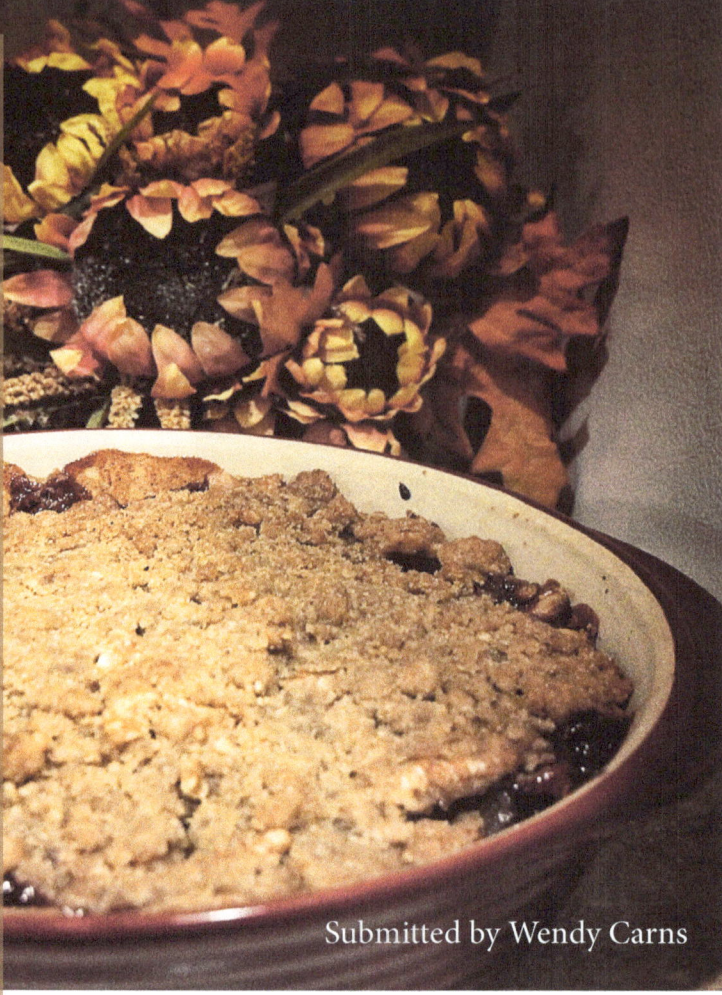

Submitted by Wendy Carns

Glazed Pumpkin Cookies

2 1/2 cups all purpose flour
1 teaspoon baking powder
1 teaspoon baking soda
2 teaspoons ground cinnamon
1/2 teaspoon ground nutmeg
1/2 teaspoon ground cloves
1/2 teaspoon salt
1/2 cup butter (softened)
1 1/2 cup white sugar
1 cup pumpkin pure (canned)
1 egg
1 teaspoon vanilla extract

DIRECTIONS:
1. Preheat oven to 350 degrees

2. In medium bowl combine dry ingredients and set aside.

3. In a seperate bowl cream together butter and sugar. Add pumpkin, egg and vanilla to the mixture and beat until creamy.

4. Mix in dry ingredients.

5. Drop cookies on a cookie sheet.

6. Bake 15-20 minutes. Cool and drizzle with glaze.

For the Glaze:
2 cups confectioners sugar
3 tablespoons milk
1 tablespoon melted butter
1 teaspoon vanilla extract

DIRECTIONS:
1 Combine all ingredients in a medium bowl. Add milk as needed. (the mixture should be light and slightly runny).

2. with a small spoon, drizzle over the top of colled pumpkin cookies.

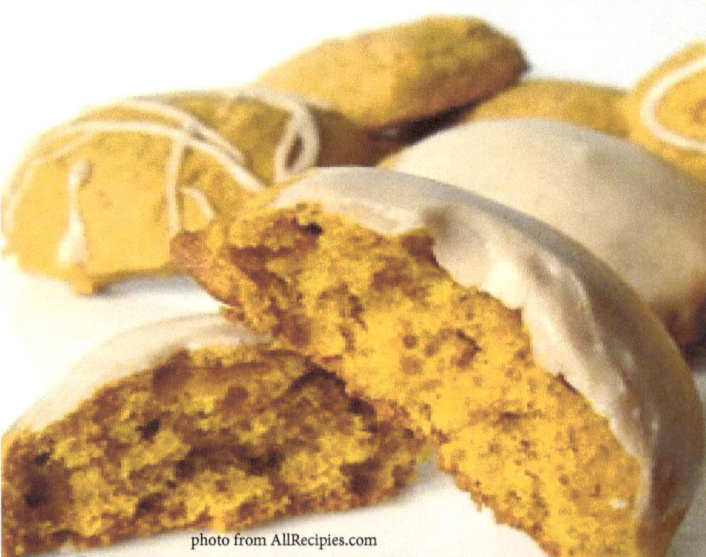

photo from AllRecipies.com

Desserts

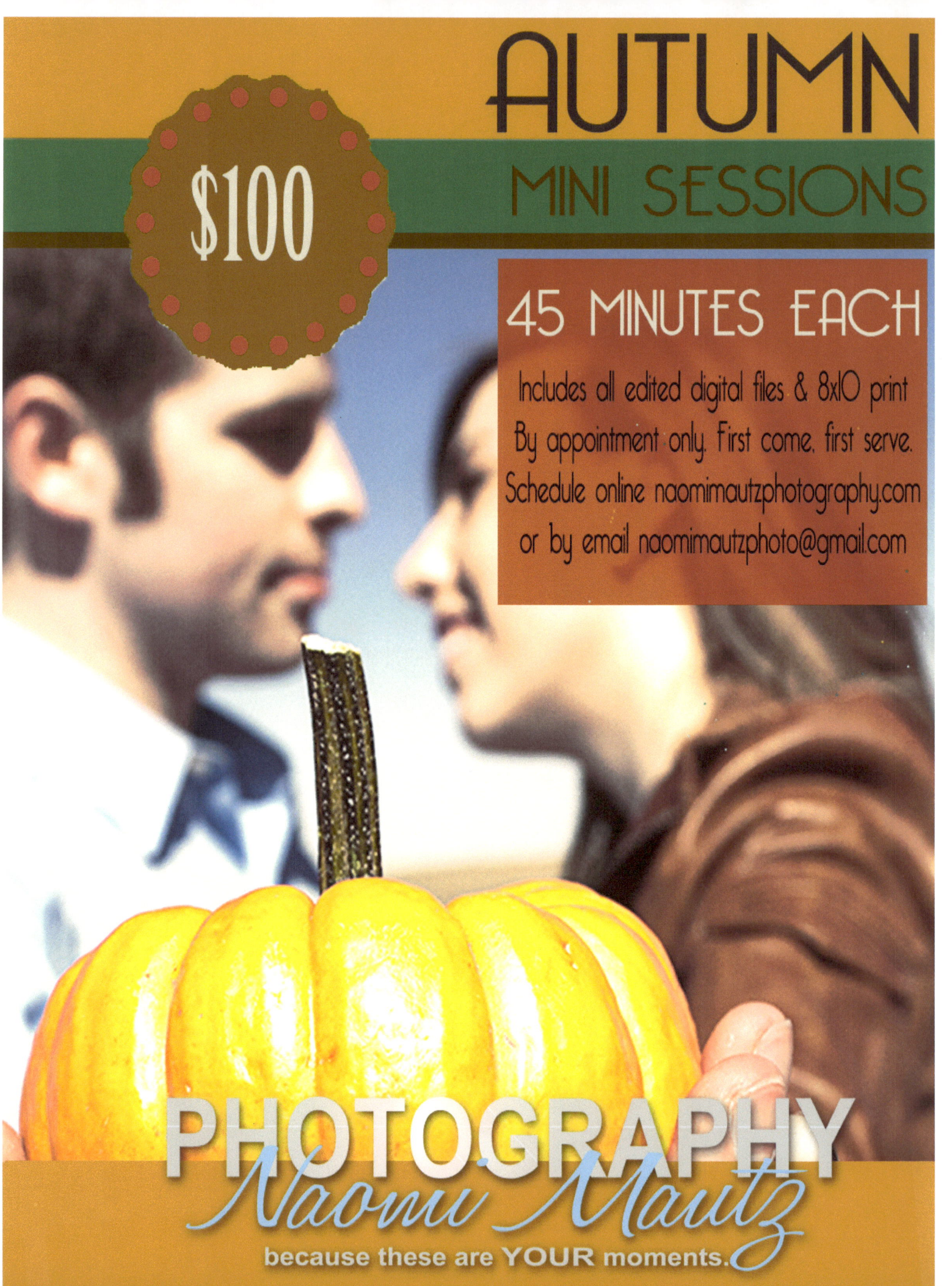

I had the opportunity to talk to these three amazing women who have dedicated their hearts and lives to the hearts and lives of the itty bitties among us. In my humble opinion, teachers are some of the true heros of the world, especially the good ones! It takes a special kind of person to be able to devote the hours upon hours of time that go into this profession. Teaching is one of the careers that does not stay at the office. Even after the time card has been punched, so to speak, most teachers go home only to pour countless "unpaid" hours into their jobs. Investing oneself in the little ones of the next generation is a wonderfully admirable and often underappreciated road to travel and I hope I speak for the masses when I say, "Thank you to all of you amazing teachers of the world who protect the tiny hearts that we entrust to your care every day!" I am convinced there is a special crown in heaven for each of you!

BY NAOMI MAUTZ

Shannon Custer

PHOTOGRAPHY BY NAOMI MAUTZ

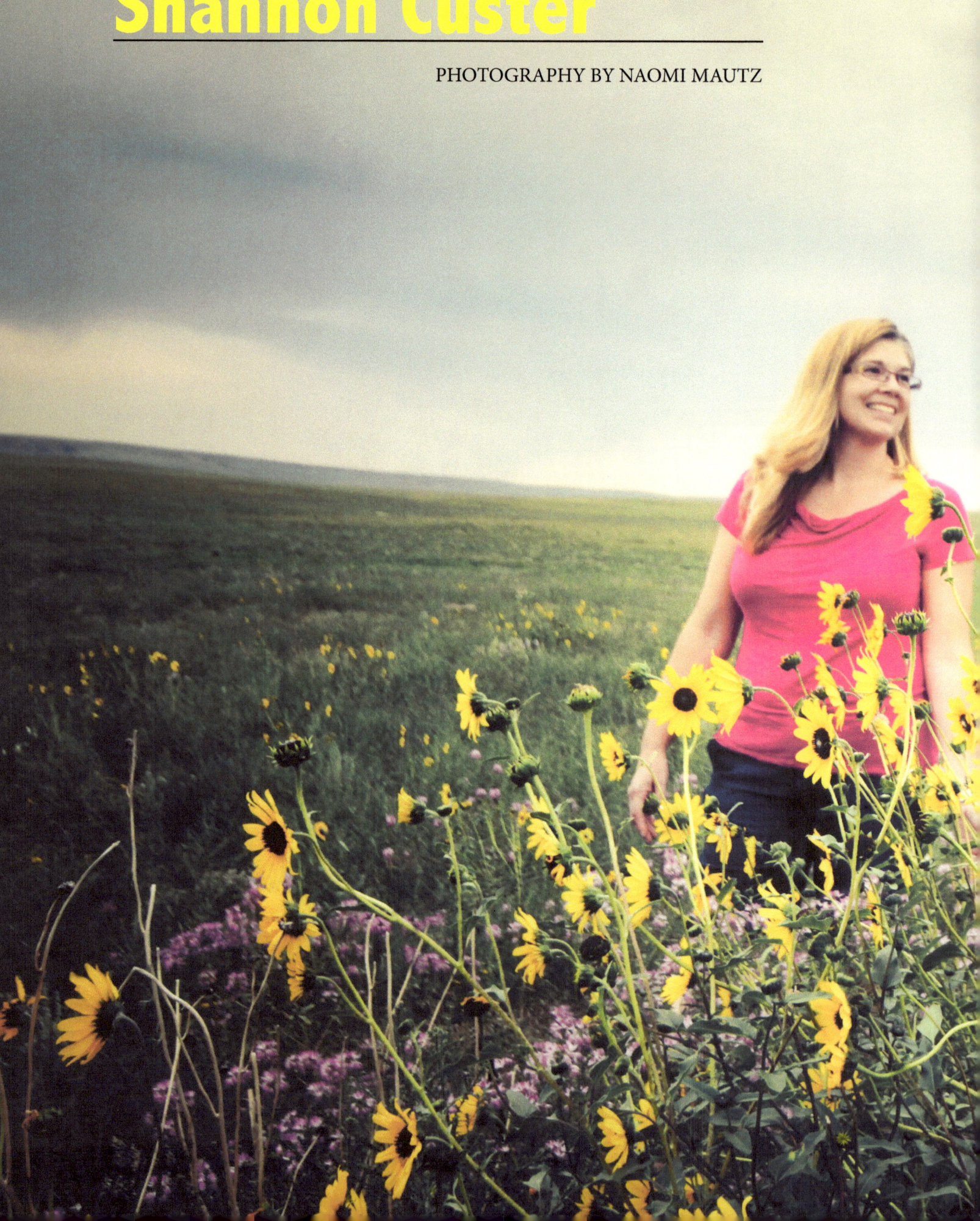

INTERVIEW

Why did you decide to become a teacher?

I grew up with a Mom who started her teaching career when we kids were all a bit older. I remember going to her classroom and helping her put up bulletin boards and plan for her week. My Mom was an amazing teacher and put so much into everything she did for her students. She was a great role model as a teacher. Even before she had her own classroom, she was a teacher at heart, and in practice, at home with us kids. Everything we did had some underlying academic value. I learned to teach through her, knowing that every activity in which we participated, was an opportunity to learn something. Our home was rich with learning opportunities and we always had fun in the process! I actually went back and forth in college about whether I wanted to become a teacher or a Social Worker. Ultimately, I got my BSW and worked in the field of Social Work, which led me into teaching with adults with disabilities in 1997. In 2007, after several Special Education jobs, I entered the UCCS and Pikes Peak BOCES Teacher in Residence program and received my teaching license. I believe God uses my Social Work training often in the field of teaching. So many of the students I have worked with have had difficult home lives and situations to overcome. I am grateful that I was granted the ability to go to school twice and use my passion for people to help others and to educate them at the same time.

What is the difference between a good teacher and an outstanding teacher?

A good teacher teaches only what he/she has been told to teach. An outstanding teacher expands upon the minimum requirements and challenges students to go deeper and farther than they "have to" or sometimes think they can.

What is the most useful advice you have ever received?

The most useful advice I ever received was not to worry about "gaps in learning." Nobody retains everything they have ever been taught. Rather, learn to use your resources. If a student knows how to find the answers they seek when they don't remember them, they can learn or re-learn anything. My father was a particular inspiration for this when I was growing up. He often told me to "read the manual." While it frustrated me at the time, I learned to be an independent learner, and really appreciate that I feel empowered to learn anything at any time. I believe today's students have such an advantage because information is so much more readily available through the internet (used responsibly, of course). I also think it is important to help students to feel empowered by the vast array of knowledge to which they have access and to truly appreciate it for the value it is to them as life-long learners.

What is the most satisfying thing about teaching?

The most satisfying thing about teaching is looking back at the end of the year and seeing how much the students have grown. This was especially fun when I taught Kindergarten. I had students start the year not even knowing their alphabet, and finishing the year reading. That always builds my confidence as a teacher, but it makes me, even more so, proud of my students.

What is the biggest challenge in teaching?

I think the biggest challenge in teaching is wondering if I did enough and that my students learned enough. Most teachers I know are type-A perfectionists. We all want what's best for our students and hope that we can give them all the tools they will need to be successful. This is an awesome responsibility that I take very seriously, but it is challenging to hold that responsibility.

What are your interests outside of teaching?

My faith and family are the two most important things in my life, outside of teaching. We love spending time together as a family, playing board games, cooking, playing with cars, and walking our two puppies. I grew up riding horses, and now that my daughter is 4 and horse crazy, I am excited to get back into the sport of my childhood.

"*An* **OUTSTANDING** *teacher expands upon the minimum requirements and* **CHALLENGES** *students to go deeper and* **FARTHER** *than they "have to" or sometimes think they can.*"

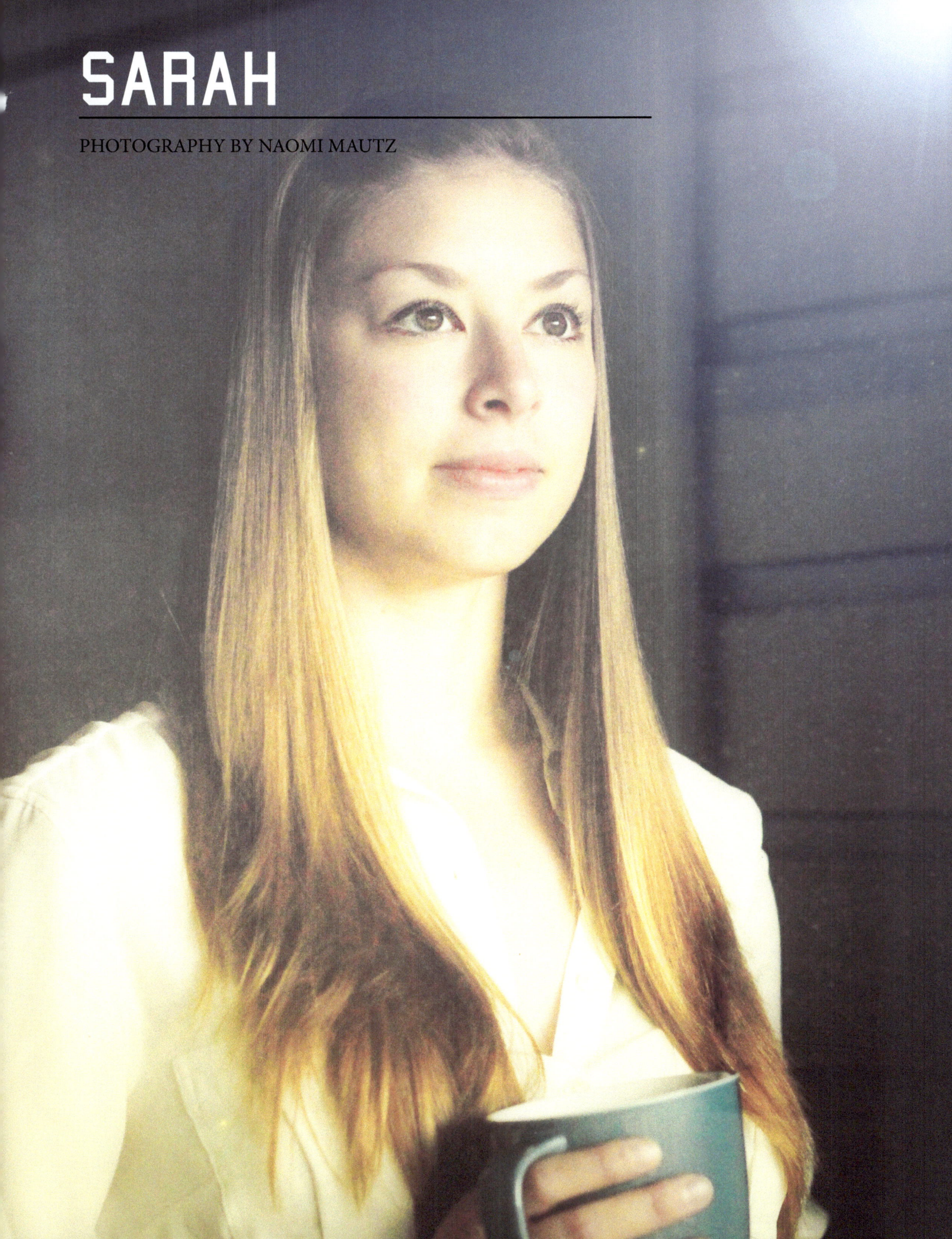

Why did you decide to become a teacher?

I love children, I have always had a passion for learning and the desire to learn, and I love being a positive influence in a child's life.

What is the scariest thing about teaching?

You are responsible for the safety and education of your group of children and that is a very heavy responsibility. You don't want to fail them or their families.

How would your students describe you?

My first graders would probably tell you that I am funny.

How do you develop self-esteem within students?

I like to tell my kiddos that everyone is an expert on something and the fun part in life is discovering your own expertise. I also work hard to create a classroom community where every student feels safe, respected, loved, and SUCCESSFUL. I am positive in the way I talk to and treat the children.

Tell us about a golden teaching moment.

I think the golden teaching moments come when you have been saying something to your kids over and over and then all of a sudden they show and say what you have been trying to reinforce all on their own and so proudly. The teachable moments that occur outside of your curriculum throughout the day are sometimes the most golden. We can't forget that we aren't just teaching, but we are growing people and teaching them how to be successful in the world with others.

Who is your biggest hero and why?

While I have many mentors, my biggest hero is my dad. I admire the way he has always lived to serve and the way he loves people. He lives out service and love in every aspect of his life and I aspire each day to do the same thing. I want people to see me as they have seen my dad and hopefully say the kinds of things I have heard said about him as well.

What are your interests outside of teaching?

I love to play and coach volleyball, running and hiking with my dog, doing anything outdoors, and spending time with my family.

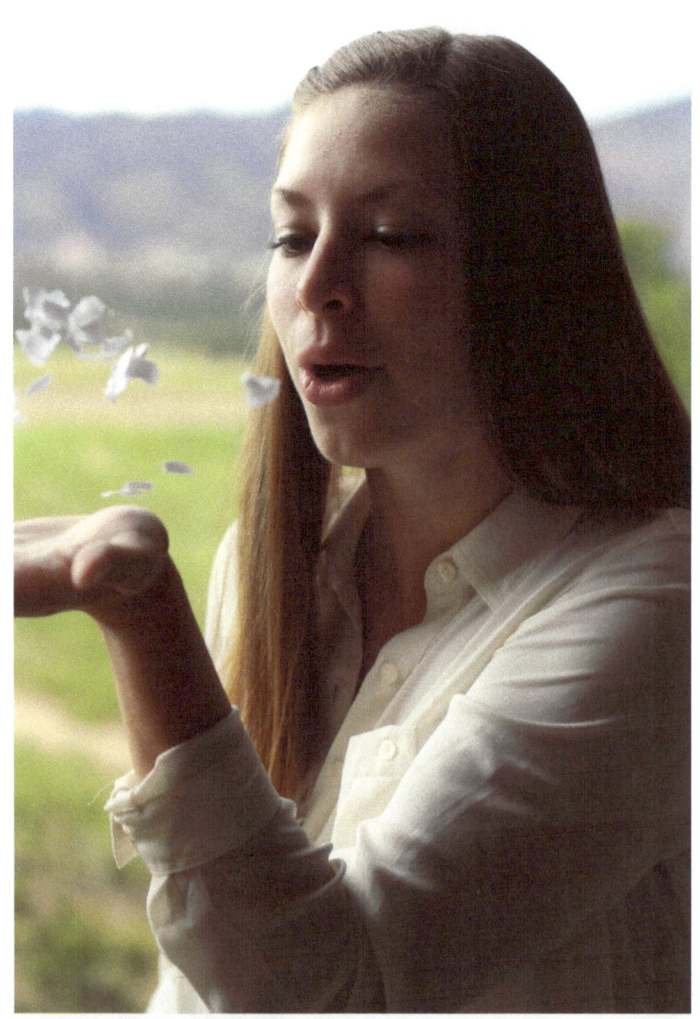

"I always tell my kiddos that everyone is an **EXPERT** at something. The fun part is **DISCOVERING** your own expertise."

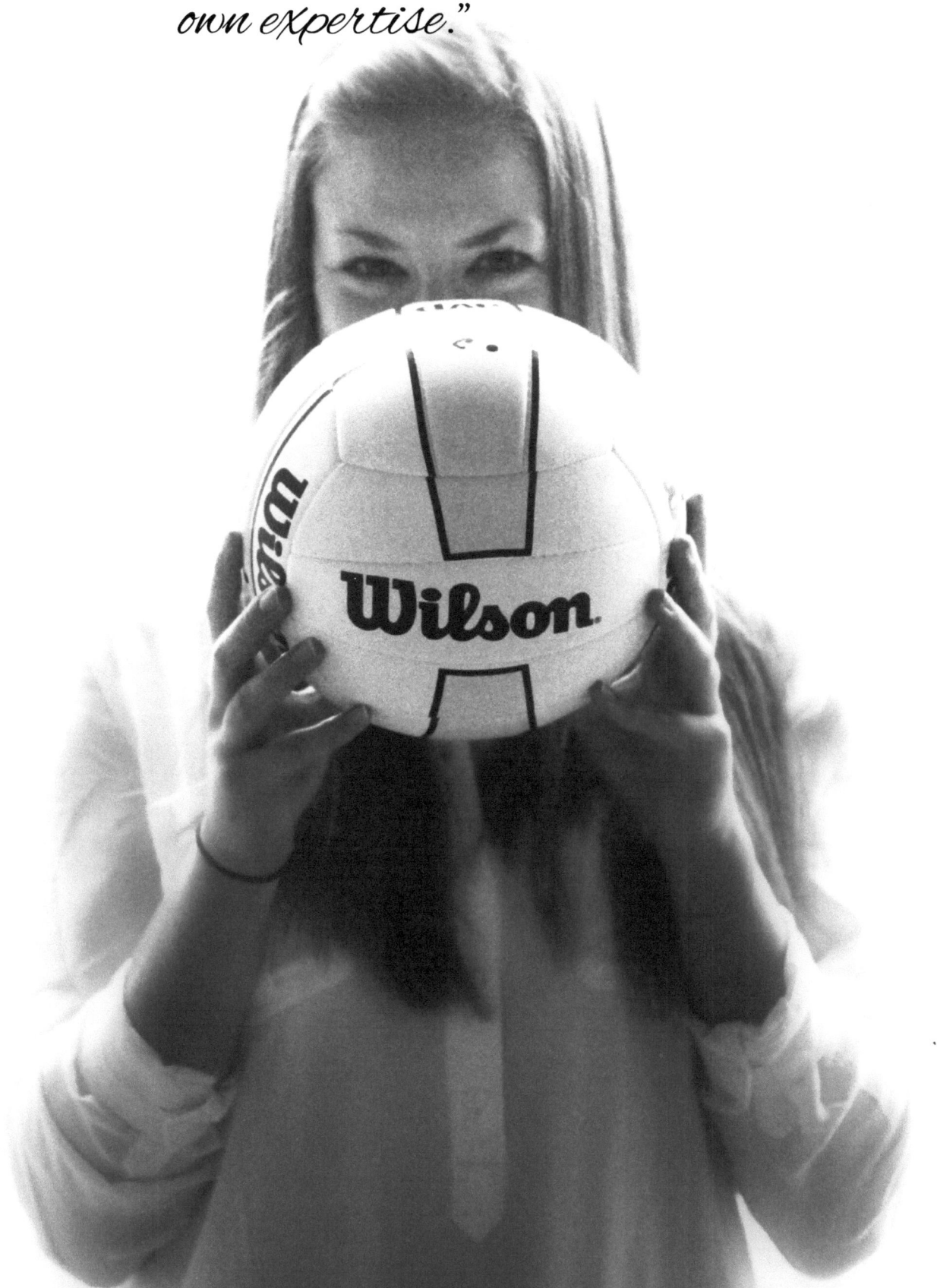

SCHOOLS IN THE UNITED STATES
DID YOU KNOW?
CENTER OF EDUCATION REFORM www.cdreform.com

UNITED STATES SCHOOLS-

There are *13, 809* School Districts in the U.S. There are *132,656* K-12 Schools with *98,706* of them being Public Schools, *5,714* being Charter Schools, *28,220* being Private Schools and *7,400* being Catholic Schools. Total K-12 enrollment in the United States is *55,235,000*, with a total of *49,266,00* in Public Schools, *1,941,831* in Charter Schools, *5,165,280* in Private Schools, *2,224,470* in Catholic School and *1,508,000* in Home School.

UNITED STATES TEACHERS-

Public School teachers in the U.S. total *3,219,458*. Public School teachers total *456,270*. Catholic School teachers total 146,630 and Charter School teachers total *72,000*. The teacher to student ratio in Public Schools in the U.S. is *15.7:1*, in Private Schools the ratio is *11.1:1* and the Catholic School ratio is *14.7:1*.

TUITION COSTS-

The average tuition for Private School is *$8,549*. Average Catholic School tuition is *$6,018*.

SALARIES AND WAGES-

Public School Superintendents receive and average salary of *$159,634*. The average salary for the Principal in a Public High School is *$97,486*, A Junior High Principal makes an average of *$91,334* and an Elementary Principal makes an average of *$85,907*. Public School Counselors bring home an average salary of *$57,800* while Librarians come in at an average of *$54,650* and the School Nurse makes an average salary of *$64,260*. Public School teachers average a base salary of *$49,630* and Private School teachers only pull an average salary of *$36,250*.

Chelsy Catterson

PHOTOGRAPHY BY NAOMI MAUTZ

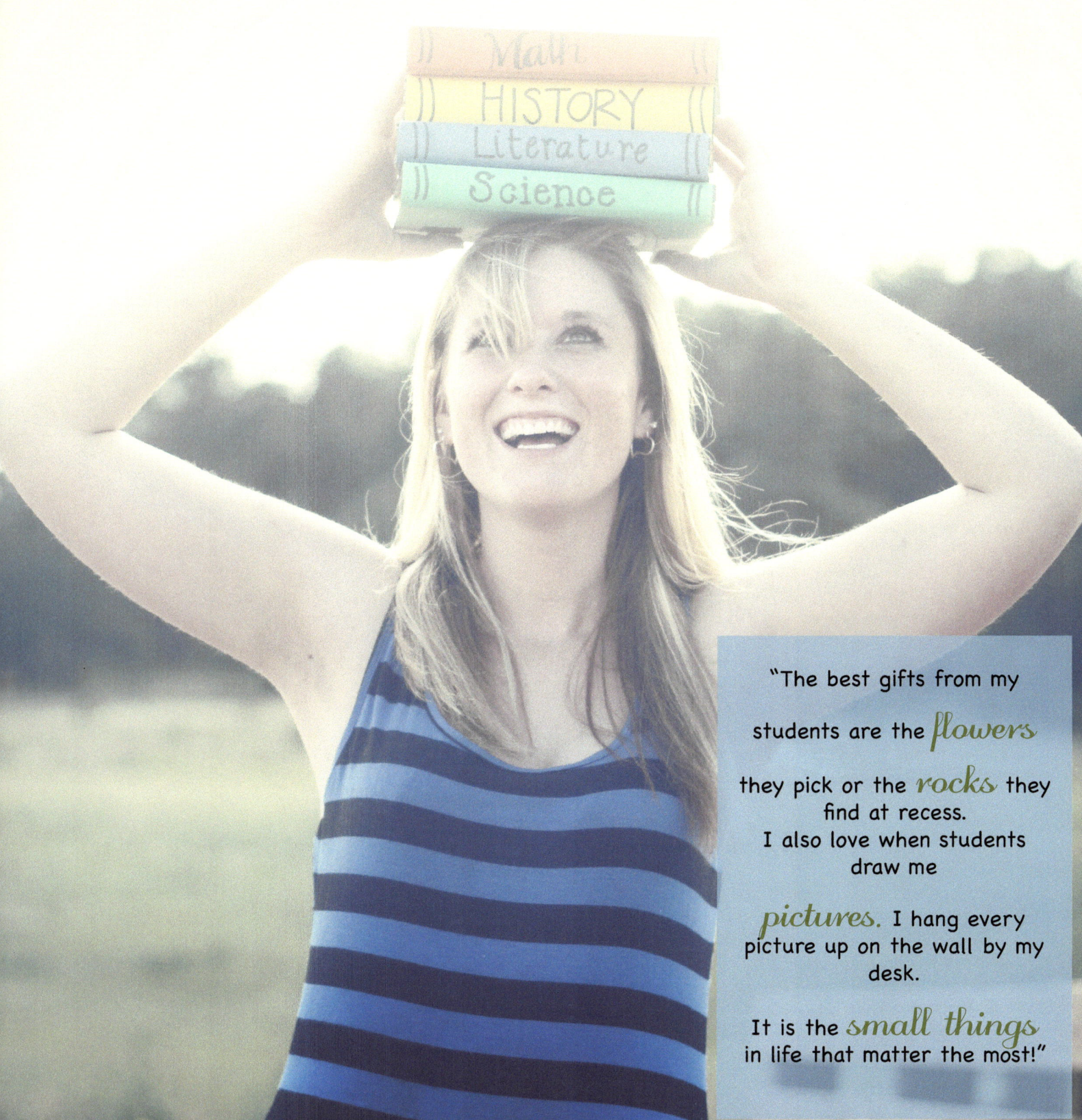

"The best gifts from my students are the *flowers* they pick or the *rocks* they find at recess.
I also love when students draw me *pictures*. I hang every picture up on the wall by my desk.

It is the *small things* in life that matter the most!"

Interview

Why did you decide to become a teacher?

I decided to become a teacher because I wanted to make a difference in the lives of children. The hearts of children are so fragile when they are little and their minds full of curiosity. As a teacher I want to help children find that love for life and for themselves. I want to bring joy to their hearts within the classroom that they can carry with them for the rest of their lives. I want my students to look back on their lives and remember me as the teacher that helped them discover a piece of their life puzzle. I also want to help aide in the student's exploration of all that curiosity that is built up in their minds. I want my classroom to be that exploration and discovery time.

Who was your best teacher and why?

My best teacher was my fourth grade teacher at Palmer Lake Elementary, Mrs. Bates. She was a young teacher who was full of life and love. She came into the school everyday ready to make a difference and not only be a teacher but a friend. She had a great balance of how to be our friend; caring, laughing, telling jokes, having fun. However, she knew when it was time to be serious and buckle down. She respected us as individuals and so in return we respected her. She genuinely cared about each of her students, and when you feel important you have more confidence in yourself to succeed. She was an all around amazing teacher!

What type of student were you in high school?

In high school I was involved in cheerleading, took college courses through the high school, and I worked hard for my grades. I didn't try to skate by or go through the daily motions; I tried to succeed in my classes and be involved in the school (cheerleading). I also was always trying to be there to help others. I have a big heart and so a lot of the time my peers would come to me for support with different situations, so I was always lending a helping hand too. I was by no means the most popular in high school though, and would keep to myself or close friends for the most part; no partying for this girl! haha

What is your biggest pet peeve as a teacher?

As a teacher I think my biggest pet peeve (as silly as it sounds) is when the students ruin their pencils. Students will purposefully break off the erasers, chew on the pencils, bend the metal around the eraser part, or purposefully break the tip off of their pencil. I am currently, since it is the beginning of the year, trying to teach my students that pencils are a tool and not a toy. However, as of now it drives me bonkers when I find a pencil with the eraser torn off (haha)!

What part of teaching do you look the most forward to?

The part of teaching I look the most forward to is watching my students grow emotionally and within academics. The students grow everyday and it is wonderful to watch their little minds begin to expand and grow with curiosity; and them willing to explore that curiosity. However, on a whole different level, I look forward to their silly jokes, laughs, smiles, and big hugs at the end of the day; they make me smile!

What is the most helpful things a parent can do?

I think the most helpful thing a parent can do is to be invested in their child's life and education. When a parent is willing to communicate with you about their child's life and education, show support and collaborate on how to best teach their child it makes a world of difference.

What is the funniest thing that has ever happened to you in the classroom?

Wow….funny things happen to me all the time. A recent funny thing that happened was that I wore my hair kind of wavy one day, rather than my regular straight hair. Well I had a little girl come up to me and say "Ms. Catterson, your hair is crazy today! Did you even brush it?"

What are your interests outside of teaching?

There is such a thing as interests outside of school? (just kidding!) Outside of school I enjoy spending time with family, friends, and my dog Butters. I enjoy camping/hiking when the weather is nice and going fishing. I also am a huge Denver Broncos fan, so watching football is a must on Sundays. Going to concerts is another joy of mine; country music is my favorite genre.

Who do you look up to and want to emulate?

I have several people that I look up to, and they have helped shape who I am today; however, I do look up to my mother, Sharil Catterson, my father Robert Catterson, and my brother Jeremiah Catterson. They always are the solid rock during the good times and the hard times. They are always there for me, pushing me to succeed and always providing support and love. They are there to share laughs or to wipe tears. I really admire my family and love them dearly. Also, my brother Jeremiah has Downs Syndrome and always has a fun and loving personality. He frequently reminds me of what is truly important in life and to not sweat the small stuff. He constantly models the life of Christ (full of love).

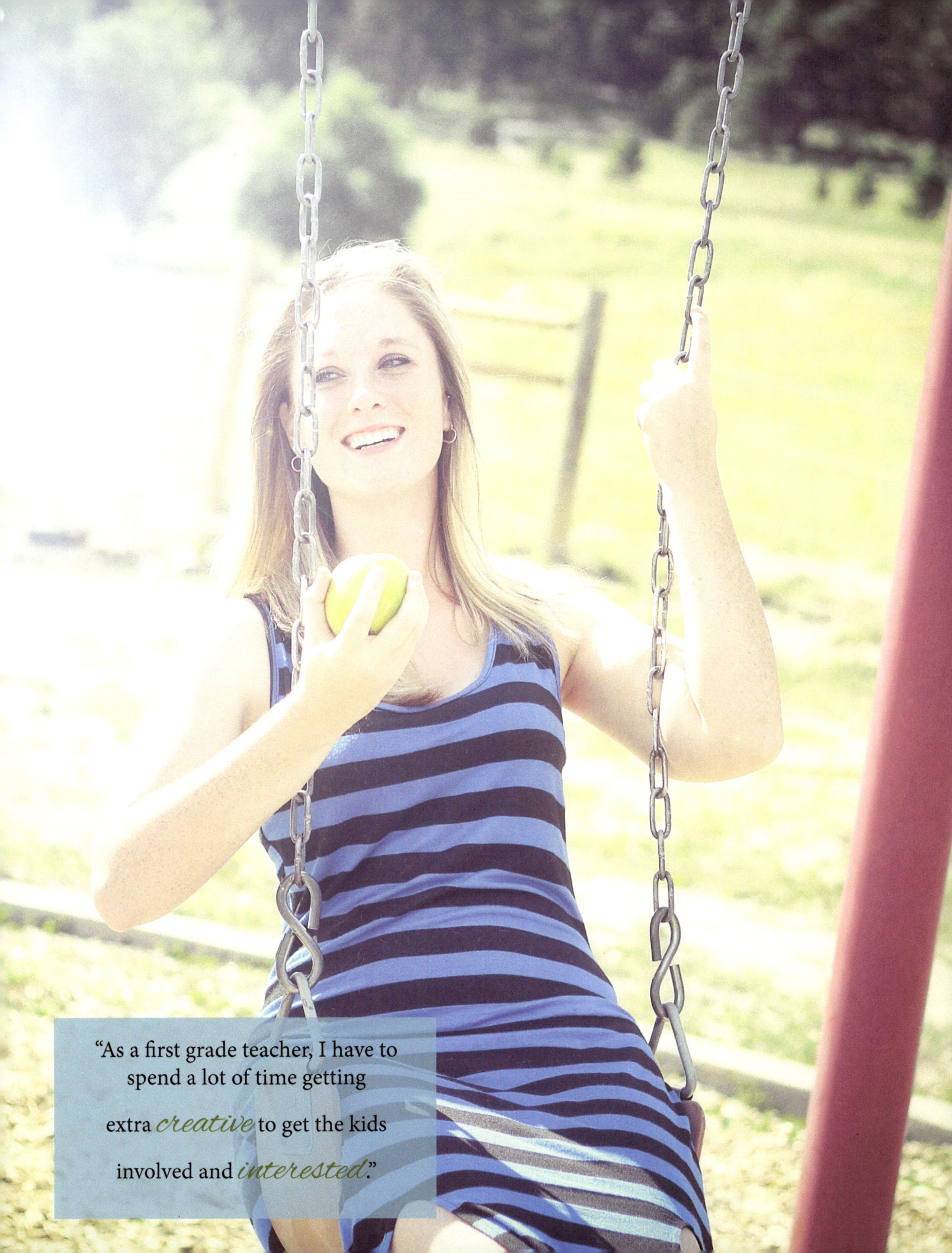

"As a first grade teacher, I have to spend a lot of time getting extra *creative* to get the kids involved and *interested*."

TOP TEN: UNITED STATES SCHOOLS

www.usnews.com

HIGH SCHOOL RANKINGS

#1. School for the Talented and Gifted
Dallas, TX.

#2. BASIS Tucson
Tucson, AZ.

#3. Gwinnett School of Mathematics, Science and Technology
Lawrenceville, GA.

#4. Thomas Jefferson High School for Science and Technology
Alexandria, VA.

#5. BASIS Scottsdale
Scottsdale, AZ.

#6. Pine View School
Osprey, FL.

#7. Loveless Academic Magnet Program High School
Montgomery, AL.

#8. Biotechnology High School
Freehold, NJ.

#9. International School
Bellevue, WA.

#10. Academic Magnet High School
North Charleston, SC.

NATIONAL UNIVERSITY RANKINGS

#1. Harvard University
Cambridge, MA.

#2. Princeton University
Princeton, NJ.

#3. Yale University
New Haven, CT.

#4. Columbia University
New York, NY.

#5. University of Chicago
Chicago, IL.

#6. Massachusetts Institute of Technology
Cambridge, MA..

#7. Stanford University
Stanford, CA..

#8. Duke University
Durham, NC.

#9. University of Pennsylvania
Philadelphia, PA.

#10. California Institue of Technology
Pasadena, CA.

ONLINE BACHELOR'S PROGRAM RANKINGS

#1. Pace University
New York, NY.

#2. Daytona State College
Daytona Beach, FL.

#3. St. John's University
Queens, NY.

#4. Westfield State University
Westfeild, MA.

#5. Graceland University
Lamoni, IA.

#6. Lawrence Technological University
Southfield, MI.

#7. Colorado State University Global Campus
Greenwood Village, CO..

#8. Brandman University
Irvine, CA.

#9. Bellevue University
Bellevue, NE.

#10. Regent University
North Charleston, SC.

Idioglossia: Twin Talk

By Katy Marturano

I'm quite fascinated by Gods miracle that is manifested in my twin nephews. I love all of my nephews dearly but the twins add a whole new element to toddler watching. Since these two were born I have been eagerly awaiting their first words. They have definitely been trying and for a while now if you asked them anything the answer was "dis" (translation: this). At almost two years old, Lucian and Landon are starting to make themselves heard, and finally, understood.

It is a common belief that twins can create their own language at an early age, communicating with each other, and rarely, others. Scientists say this is Idioglossia (technical term for "twin talk"), and that it is a myth. They say that twins, especially identical twins, just share so many things such as DNA that they share similar thoughts more often than not. This makes me wonder if any scientist has sat with twins before; because I've seen the "twin talk" in action, and let me tell you those two little boys have been talking and laughing at inside jokes for a while now. Only the two of them are in on it, the rest of us are on the outside scratching our heads.

Most of what they say is still "babinese" (technical term for "baby talk") and not words at all, it's just them mimicking what they think passes as conversation. I enjoy reading to them quite often hoping they catch on to more words. When I listen closely I have been catching more and more words and sometimes small phrases from the boys.

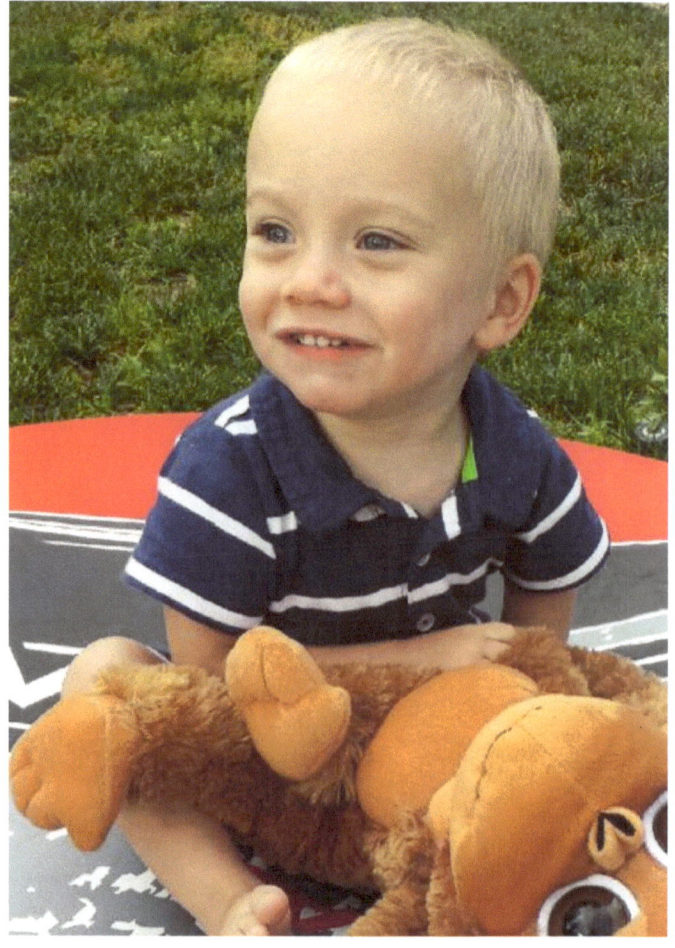

A couple of days ago, as we headed out of the house, Landon bravely approached the steps, smiled at me, and said proudly, "I got dis." I was so thrilled at what I heard I let him walk him down the stairs with me at a safe distance. Lucian has picked up his own phrases as well. While Landon was protesting a much needed diaper change Lucian came to his rescue, "Here, you want dis?" He was offering his brother a toy. As you can see, everything is "dis" but at least they're adding a few more words to it.

Trying to teach them new words is one of my favorite ways to pass the time. We're still working on saying their names and every now and then they get it right. It's hard to get them to break the habit of just gesturing to whatever they want and getting them to use their words but every day they surprise me with something new. I'm truly blessed to get to watch these two learn how to speak and share their own thoughts with the world.

ADVERTISE YOUR BUSINESS HERE

Contact Michael Mautz. mjmmedialab@gmail.com. 719-321-1161

Credits

STACI ELDEREDGE * CAPTIVATING
LAMOURE TOWNSHIP * THE GREY SCHOOL
AMAZON.COM
ERICA ARNDT * HOMESCHOOLING 101 @ CONFESSIONS OF A HOMESCHOOLER
ASHLEY ROE @ PINK PAPAYA
T. ANTHONY CONSTRUCTION
COLORADODECKBUILDERS.COM
NIELSON DESIGN AND FABRICATION LLC
PHILLIPMARTIN.COM
ALLRECIPIES.COM
CHRISTINE FISCHER
USNEWS.COM
CENTER OF EDUCATION REFORM @ CDREFORM.COM

www.ingramcontent.com/pod-product-compliance
Lightning Source LLC
Chambersburg PA
CBHW050739180526
45159CB00003B/1287